#OMBook

by Nick Entwistle
@OneMinuteBriefs

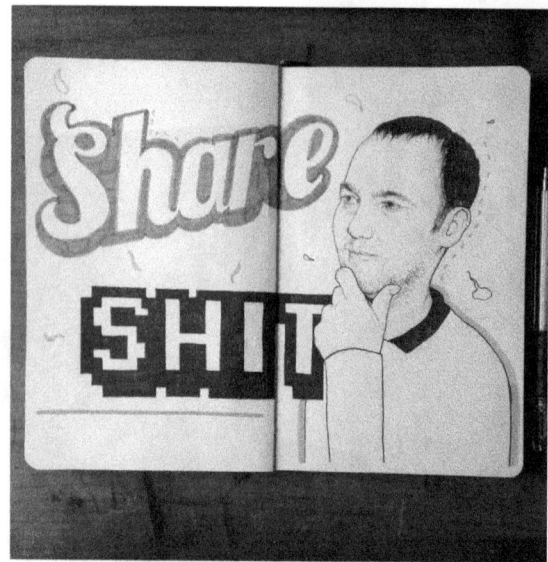

Image illustrated by @WantSomeStudio using Nick's quote of advice for creatives on social media.

About the creator

Nick Entwistle

Nick produces concepts for major brands and agencies around the UK in his role as a freelance advertising creative.
As well as this, he runs popular Twitter feeds @AgencyQuotes, @BOC_ATM and, of course, @OneMinuteBriefs. He delivers talks and workshops for the likes of D&AD and BBC and has had his work recognised by Theo Paphitis, Downing Street and won various creative awards.

interest@bankofcreativity.co.uk

Copyright © 2015 One Minute Briefs Ltd.
All rights reserved. No part of this book may be reproduced in any form or by any electronic or mechanical means including information storage and retrieval systems, without permission in writing from the authors. Ads featured are mainly spec work.

Twitter:
@OneMinuteBriefs

Website:
www.oneminutebriefs.co.uk

CONTENTS

OMB IN BRIEF	4
OMBEGINNINGS	7
OMBFORD DICTIONARY	11
OMBRANDS	15
OMB AWARDS	19
OMB HALL OF FAME	25
OMBLES	77
OMB TESTIMONIALS	85
OMB F.C.	101
OMBROKEN HEART	105
OMB ON TOUR	117
OMB TWEETS	127
OMB LIVE	139
OMBITS 'N' PIECES	149
GOT A MINUTE?	153

ONE MINUTE BRIEFS IN BRIEF

"I NEVER DID A ONE MINUTE BRIEF"

— JUNIOR COPYWRITER, AGED 80.

One Minute Briefs promotes brands and charities via social media by challenging our creative community on Twitter to respond to a brief in 'One Minute' and reward the best ideas. When people publish their ideas, they are shared by ourselves and their followers which creates a snowball effect generating hundreds of thousands of mentions per day which is all positive advertising content for the client. This enables the brand to engage with a large audience very quickly. It is also a great tool for educational workshops, talks, events and is a popular social network for the creative industry.

Using a social platform to create user generated content means that the reach is huge for brands/charities and we get a lot of exposure as a result. As well as this, our followers are able to network, receive awards/prizes and get international recognition. This makes it a positive experience for everyone involved and we are proud to see it grow as we approach 10,000 followers on Twitter.

This book has been created to document the journey OMB has been on so far and to celebrate the fantastic people we've met, as well as the things we've had the privilege of experiencing along the way. We hope you enjoy the amazing ideas on display as much as we do.
- @OneMinuteBriefs

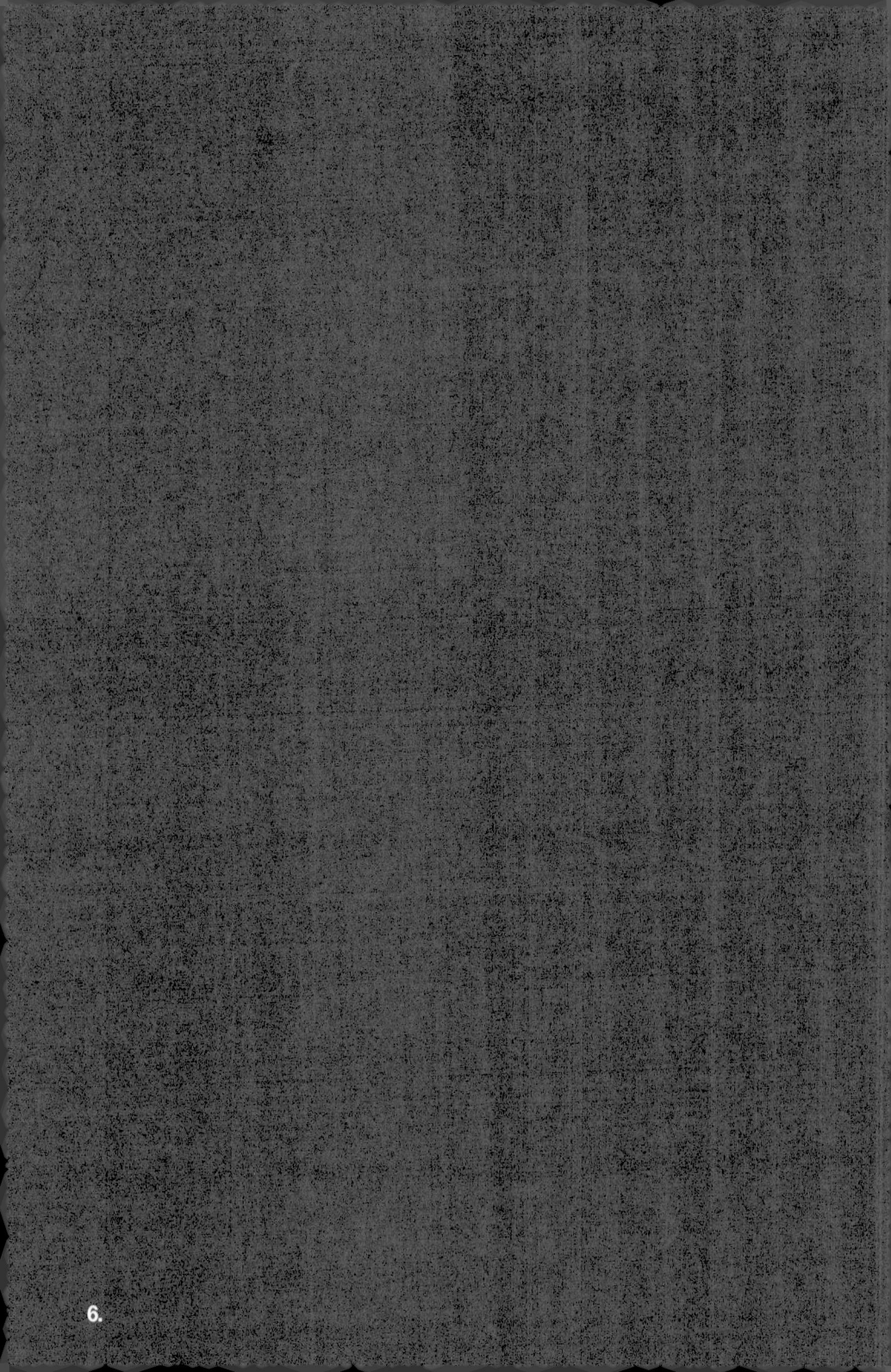

OMBEGINNINGS

Where did the idea for One Minute Briefs come from?

ONE RULE.
ONE MINUTE.
ONE AD.

One Minute Briefs was first created during a university brief a few years ago. We had an unrealistically long deadline and almost had too much time on our hands to come up with a concept. So, we decided to randomly try to crack the brief in 'one minute'.

It was just a bit of fun and a spur of the moment thing. However, the results were very interesting. One of us had come up with a corker of an idea and one of us had come up with a really really shit one. But that was the beauty of it, it didn't matter how bad the idea was as we'd only taken a minute.

We began to use the technique more and more during everyday work and our concepts began to improve. The restriction of doing ideas in one minute stopped you over-thinking and strangely gave you more freedom. No longer were we afraid of putting an idea down on the page incase it wasn't good enough. And, to this day, we use this way of working and have seen the followers of @OneMinuteBriefs rapidly improve their creative thinking as a result of getting involved each day.

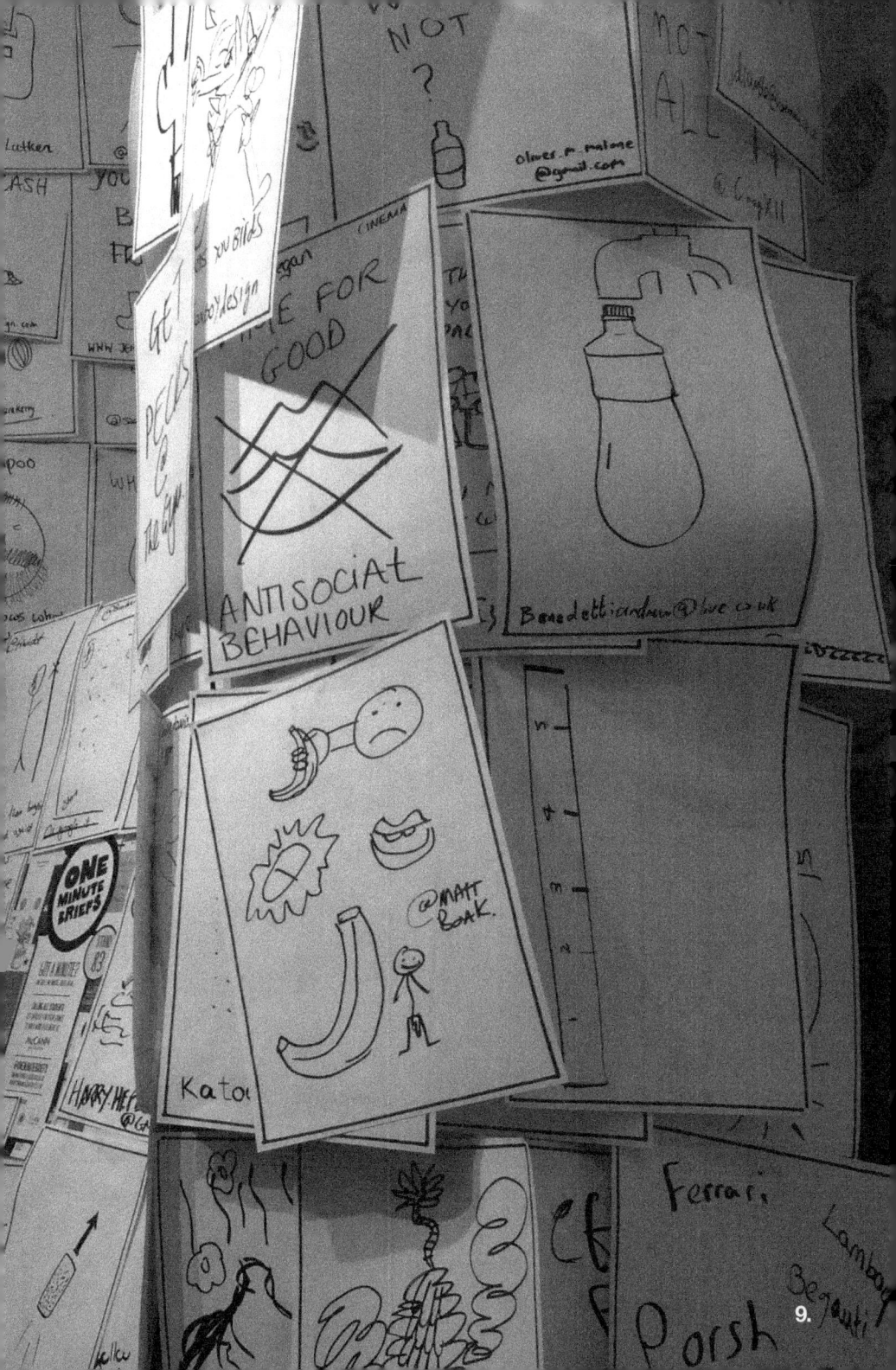

OMBFORD DICTIONARY

Our followers have their own language. Big thanks to @dr_draper for putting together this guide to help understand their OMBLEness.

OMBIe
Like a creative, but faster.

wOMB
The part of an OMBIe where ideas are conceived.

OMBillable
Creating OMB entries while on the clock at your day job.

bOMB
An entry that explodes on impact. 5 retweets, 15 faves. Almost never wins.

tOMB
The grave for OMB entries that don't make it.
As in: "My entry isn't on the blog – that's another one in the tOMB".

zOMBie
A rotten idea that just won't quit as it hungers for the taste of a creative mind.

grOMBle
What you feel like doing when your killer idea is beaten by a dodgy double-entendre.
As in: "I thought I was a shoo-in today, but I guess I mustn't grOMBle".

fOMBle
When two OMBles take creative partnership to the next level.
As in: "Yeah, we had a bit of a tamper and a fOMBle at OMB Live".

OMmmmmmB
The expression of contentment uttered by Nick upon seeing his followers spend all night together.
Alternative meaning: the sound of two OMBles having a fOMBle.

wOMBler
The tantrum thrown by an aggrieved OMBle after learning that they haven't won.

OMBRANDS

A selection of some of the
companies and charities
we have collaborated with.

FOCUS

Cheerios

THE CYBERSMILE FOUNDATION www.nabs.org.uk

The LADbible The Art of New Business

WE ARE MACMILLAN. CANCER SUPPORT

 Creativepool

18.

OMB AWARDS

Fresh Awards – Gold – Innovation – 2013

NABS Hub David Pilton Challenge Finalist – 2013

Own Category at Chip Shop Awards – 2013

Cannes Lions BBC Media Academy – Highly Commended – 2014

Featured in New York Times – 2014

The Pitch – Top 100 Small Businesses – 2014

Great British Entrepreneur Award – Finalist – 2014

MPA Awards – Creative Innovation – Finalist – 2014

Special Invitation to Downing Street – 2014

SBS Winner – Theo Paphitis – 2014

Fresh Awards – Social Media Campaign – Bronze – 2014

Fresh Awards – Breakthrough – Gold – 2014

Fresh Awards – Social Networking – Gold – 2014

Fresh Awards – Fresh Faces of Advertising – Specialist Award – 2014

NABS – Centurion Award Winner – 2015

UK Agency Awards – Best Social Campaign – Shortlisted – 2015

UK Agency Awards – Best Content Marketing – Shortlisted – 2015

OMB HIGHLY COMMENDED BY MPA

We were delighted to be highly commended by the MPA in their 'Next Big Thing' category and shortlisted alongside major agencies for Creative Innovation.

OMB GET FRESH

It was a fantastic year for us at Fresh as we picked up several awards for One Minute Briefs and even won a specialist award for Fresh Faces of Advertising. We were pleased to get the recognition for our efforts and reward the OMBLES for their continued support.

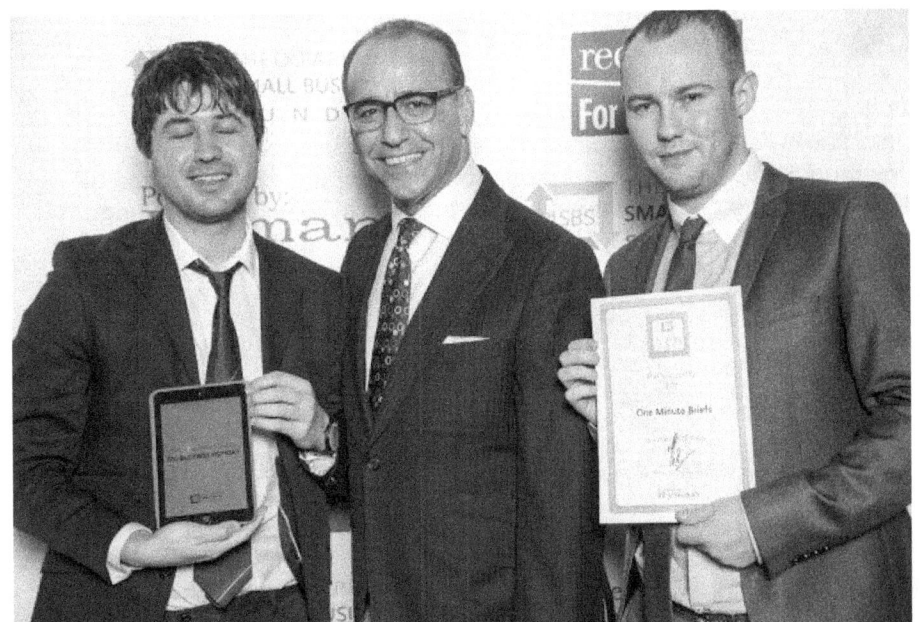

We waited for over an hour to get a picture with Theo and @Katesteeth got tired and fell asleep. I think the photographer did too as he chopped off half my head!

THEO PAPHITIS CHOOSES OMB AS AN #SBS WINNER

Every Sunday, Theo Paphitis chooses 6 small businesses that are making a difference in their industry and we were pleased to be announced as one of them. This has opened up lots of opportunities for us to collaborate with fellow businesses and it was brilliant to take one of our followers, Nick Harrington, along to the award ceremony.

OMB VISIT DOWNING STREET

As part of our work in raising awareness of the Liam Fairhurst Foundation, we received a special invite to Downing Street which was an absolute honour and to meet some of the people who have been helped by the charity was a real privilege.

"I first emailed Nick and James completely out of the blue, asking if they were able to support the foundation through One Minute Briefs. From the offset Nick and James were enthusiastic in supporting the cause and helping the charity gain a whole host of promotional material (Banners, Posters etc). Nick and James' brief captured the heart of the foundation and its meaning, making the entries beyond what we could have ever expected from any huge marketing agency. Everyone at the charity is incredibly thankful to Nick, James and all those that sent in there ideas throughout our collaboration, we use much of the material to this day."
- Callum Fairhurst
Liam Fairhurst Foundation

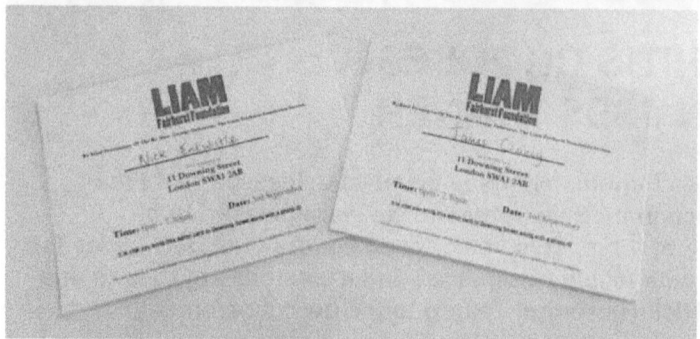

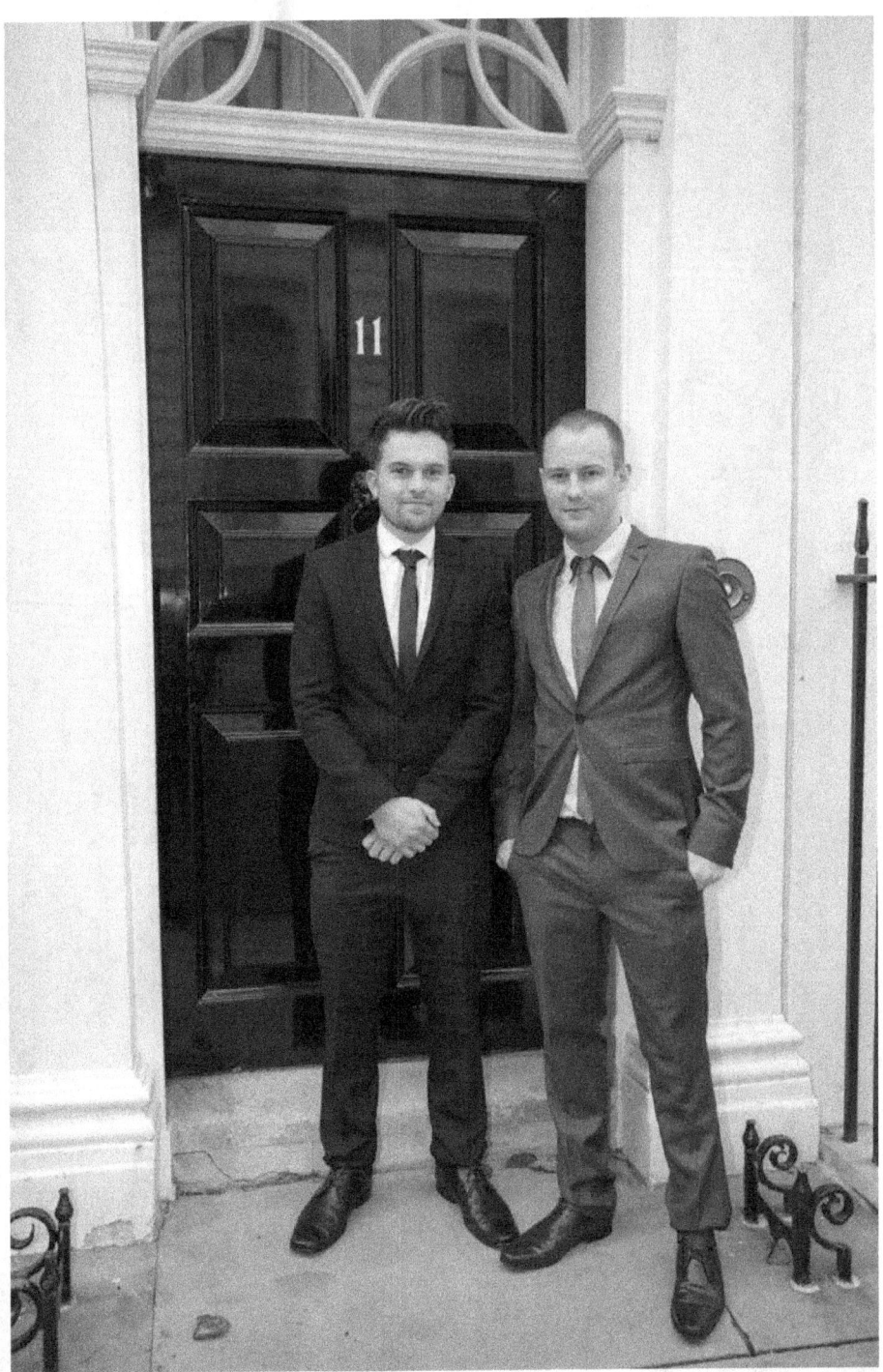

OMB HALL OF FAME

Of course, the main thing about OMB is the ideas, and here are some of our favourites in all their glory.

One Minute Brief of the Day:
Advertise International Coffee Day

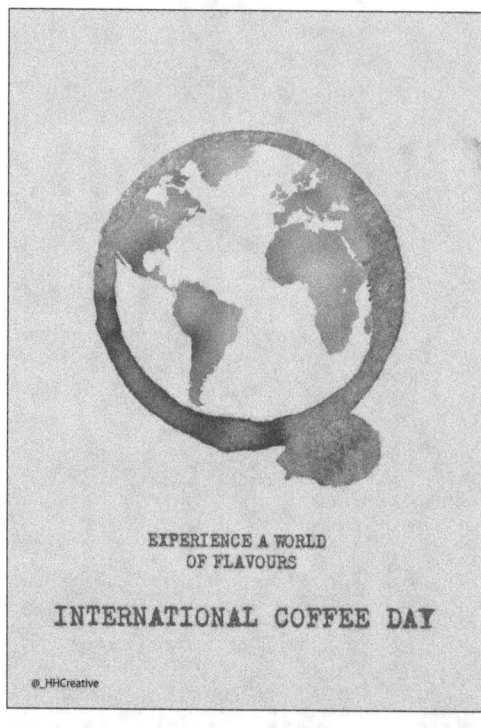

One Minute Brief of the Day:
Advertise a new use for redundant tax-disc holders

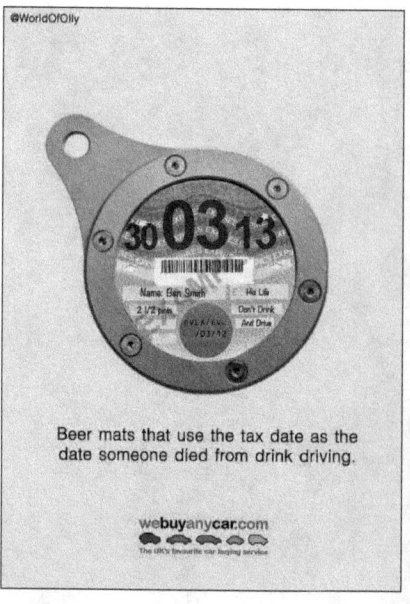

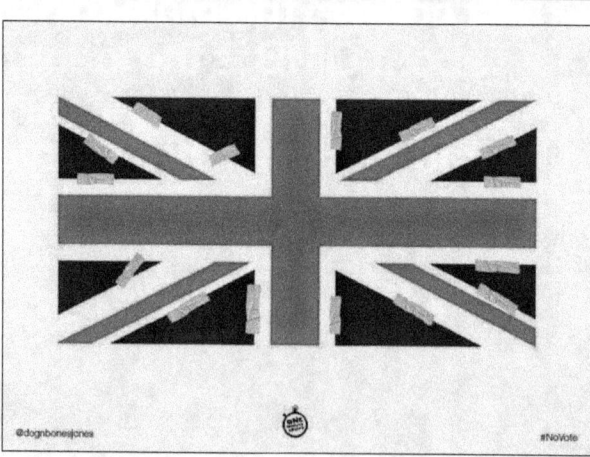

One Minute Brief of the Day:
Campaign for a #NoVote on Scottish Independence

One Minute Brief of the Day:
Advertise Circumcision

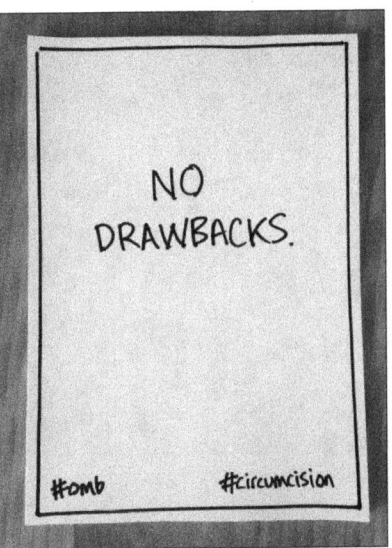

One Minute Brief of the Day:
Advertise Anti-Snoring Strips

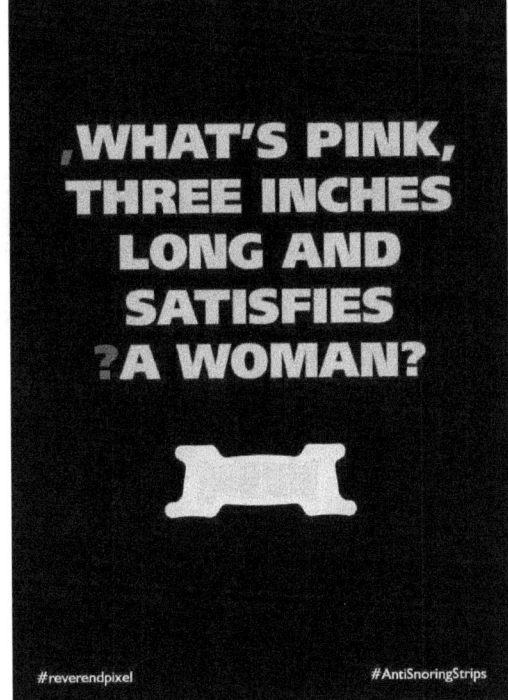

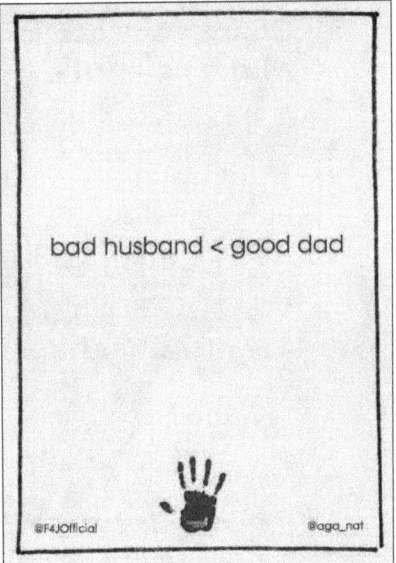

One Minute Brief of the Day:
Advertise Fathers 4 Justice

One Minute Brief of the Day:
Advertise Cinemas

LOVE FILM, HATE BUFFERING

#CINEMA

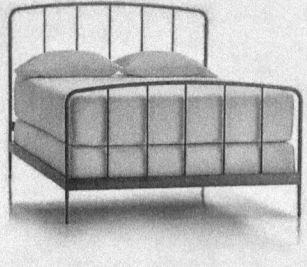

Share your bed with a celebrity.

Perfect for when you have a friend over for coffee.

Or "coffee".

sofabeds.co.uk

One Minute Brief of the Day:
Advertise Sofa-beds

The #CBB Furniture Sale - now on.
www.gumtree.com/cbb

One Minute Brief of the Day:
Advertise the Gumtree/Big Brother furniture sale

28.

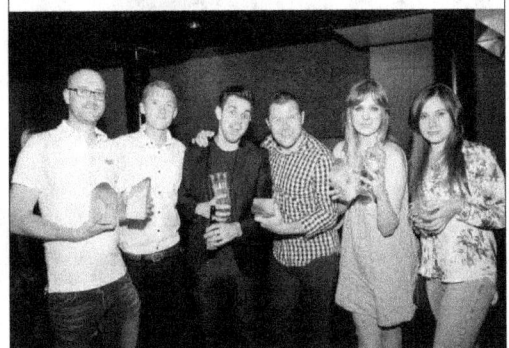

One Minute Brief of the Day: (both)
Campaign to help One Minute Briefs
win The Pitch UK award

A series of **Ads**

Funny **Ad**

Thoughtful **Ad**

Killer **Ad**

Adam Playford - Creative. Call me maybe.

@little_scamp85

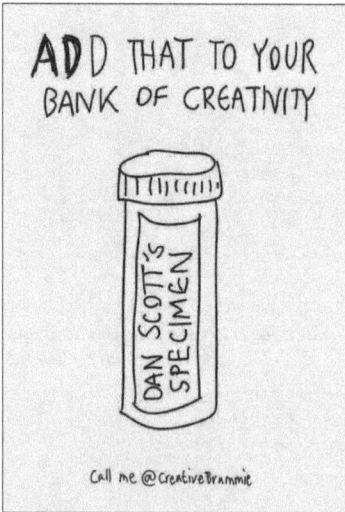

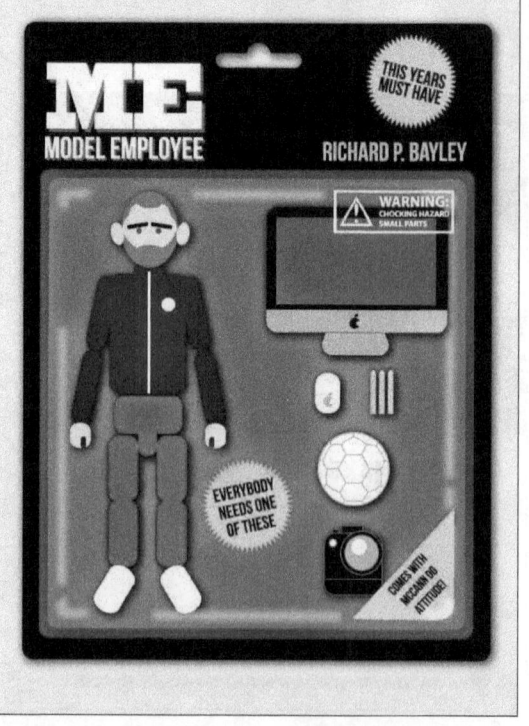

One Minute Brief of the Day: (all)
Advertise Yourself

One Minute Brief of the Day: (all)
Advertise Driverless Cars

FOR WHEN THE SHIT HITS THE PAN.

#TOILETBRUSHES @JAMESRING

BOG STANDARD

One Minute Brief of the Day: (both)
Advertise Toilet Brushes

One Minute Brief of the Day: (all)
Advertise Pornhub

One Minute Brief of the Day: (both)
Advertise Telescopes

One Minute Brief of the Day:
Advertise National No Smoking Day

One Minute Brief of the Day:
**Advertise the
'A Beautiful Constraint' book**

One Minute Brief of the Day:
Advertise Spoons

One Minute Brief of the Day: (both)
Advertise Corsets

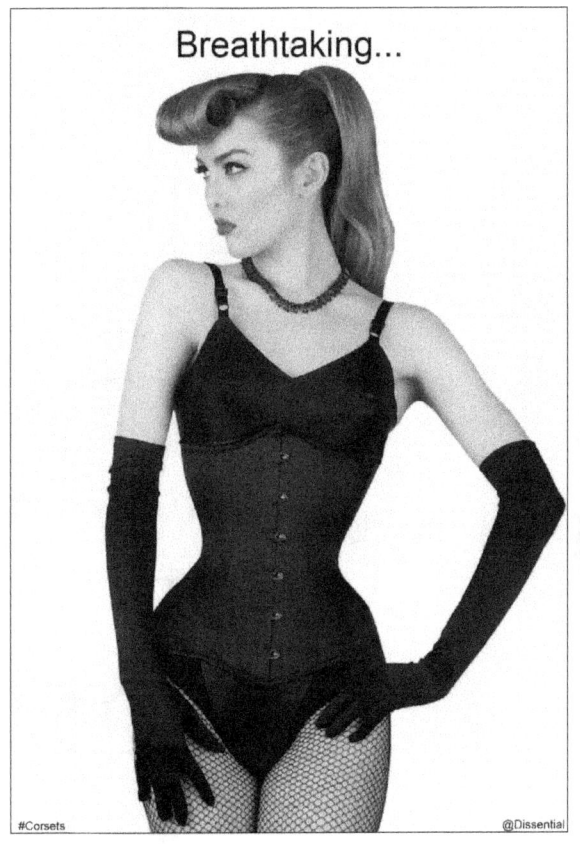

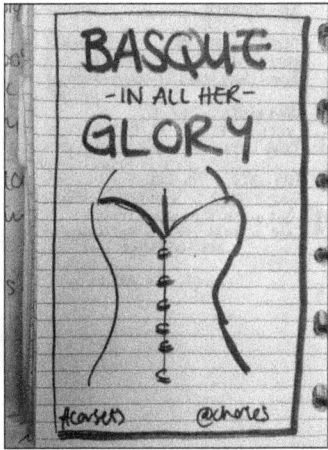

One Minute Brief of the Day:
Campaign against drink driving

One Minute Brief of the Day:
Advertise Christmas Trees

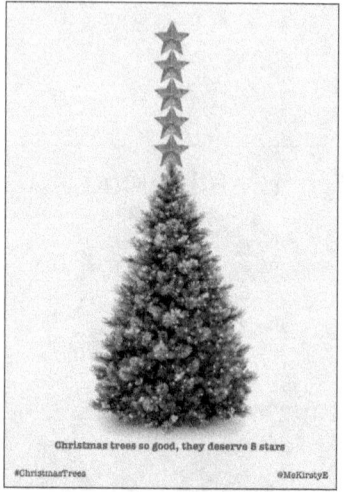

One Minute Brief of the Day:
Advertise the Ashes

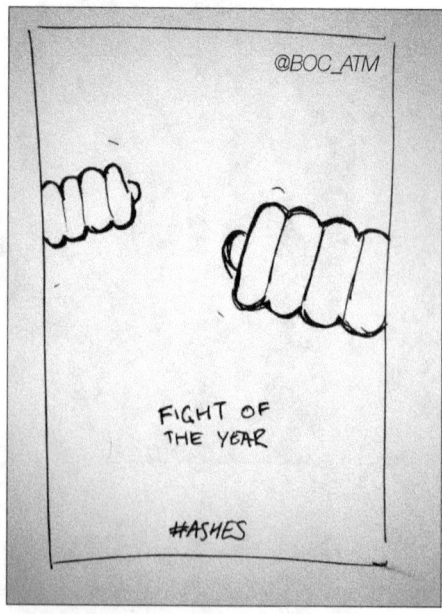

One Minute Brief of the Day:
Advertise The Ad Pad

BORDERLINE
GENIUS

THE AD PAD©

IDEAS START HERE

@alvo_muses

One Minute Brief of the Day:
Advertise Deoderant

@Jay_Pegg

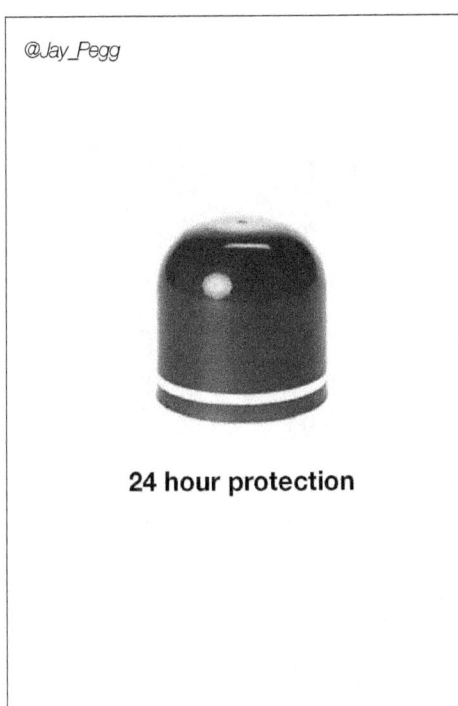

24 hour protection

Wunderbar!

@stephenhunter21
#BreastImplants

One Minute Brief of the Day:
Advertise Breast Implants

One Minute Brief of the Day:
Advertise Pies

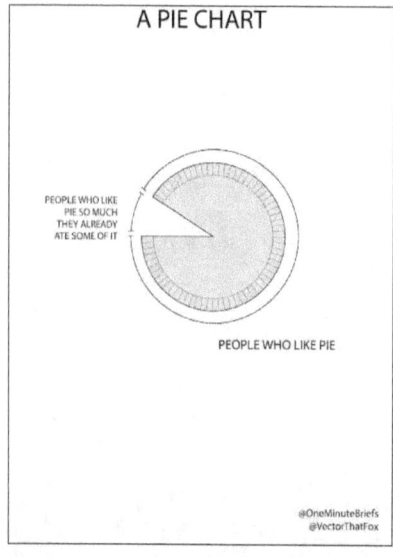

One Minute Brief of the Day:
Advertise Jagerbombs

One Minute Brief of the Day:
Advertise Twitter

One Minute Brief of the Day:
Advertise Jagerbombs

@dognbonesjones

Because you wouldn't be seen dead in anything else.

luxurycoffins.com

#coffins

One Minute Brief of the Day:
Advertise Coffins

One Minute Brief of the Day: (both)
Advertise Yoga

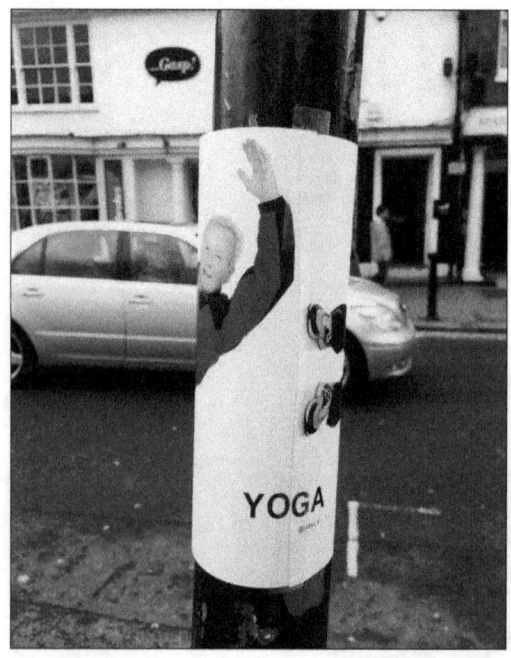

One Minute Brief of the Day:
Response poster for Nelson Mandela

One Minute Brief of the Day:
Advertise Yourself

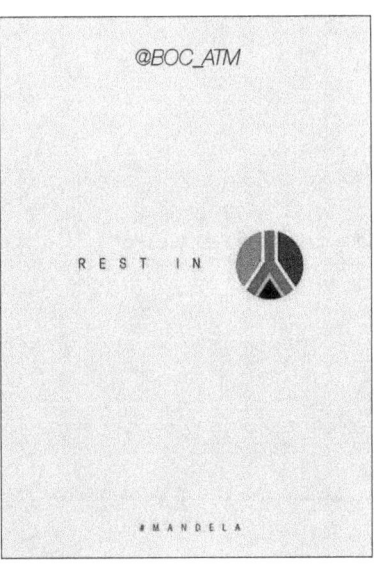

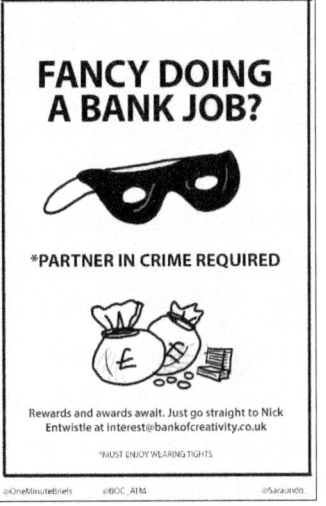

One Minute Brief of the Day:
Campaign to find a new creative partner for the Bank of Creativity

One Minute Brief of the Day: (all)
Advertise Mobile Hairdressers

@jimbobaggins75

Free blow dry

Mobilehairdresser.co.uk
07792 223 554

Dry scalp treatment

Mobilehairdresser.co.uk
07792 223 554

10% OFF
your first appointment

Mobilehairdresser.co.uk
07792 223 554

One Minute Brief of the Day:
Advertise 'Spectre' the new Bond film

One Minute Brief of the Day:
Advertise new 'Cloggs' store opening

One Minute Brief of the Day:
Advertise Pumpkins

One Minute Brief of the Day:
Campaign against cyber-bullying

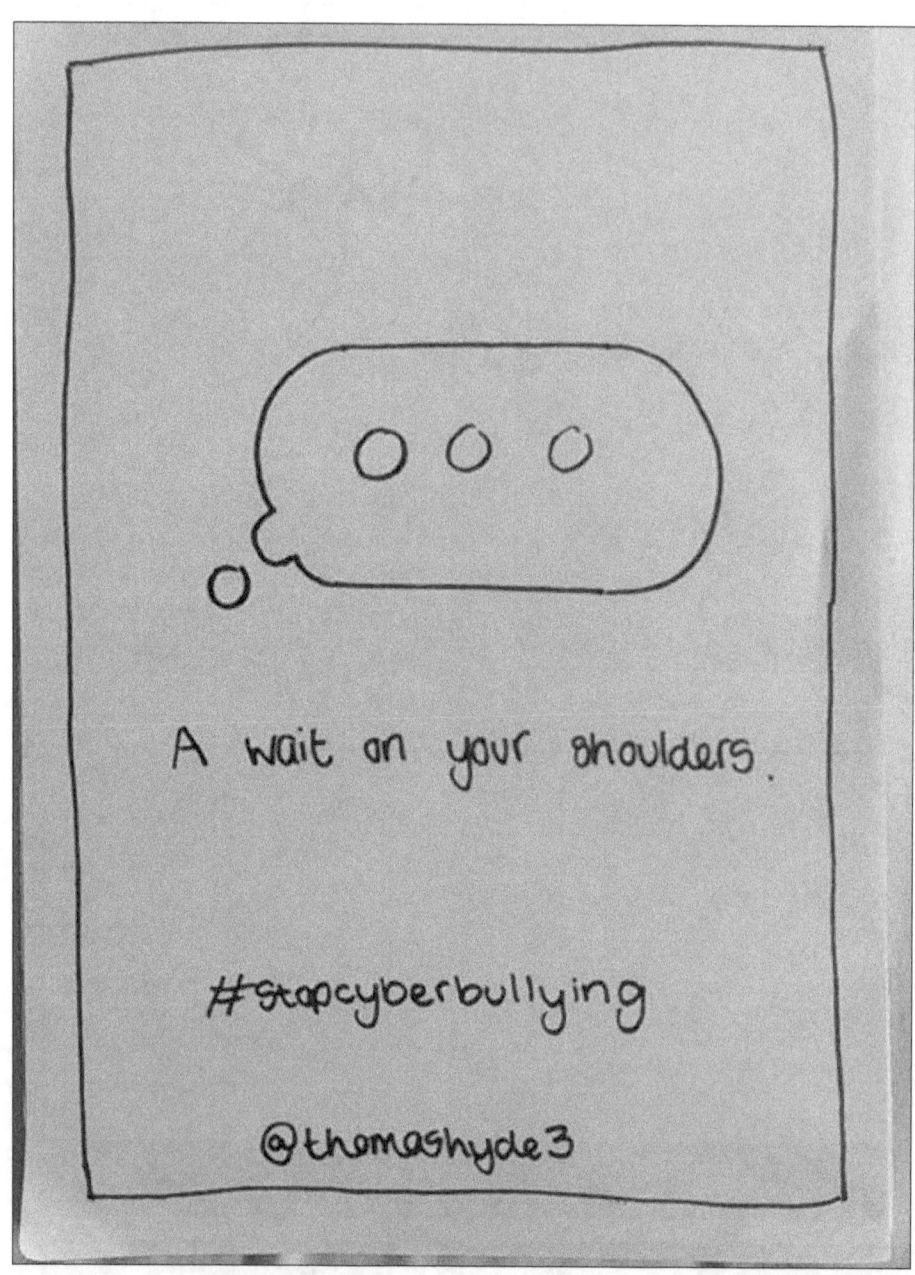

One Minute Brief of the Day:
Advertise Hot Tubs

One Minute Brief of the Day:
Advertise JCB

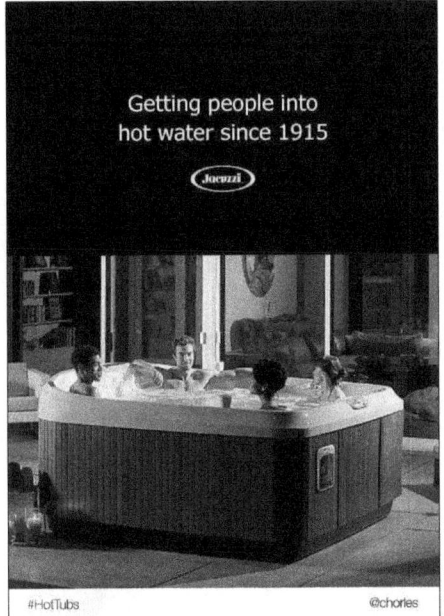

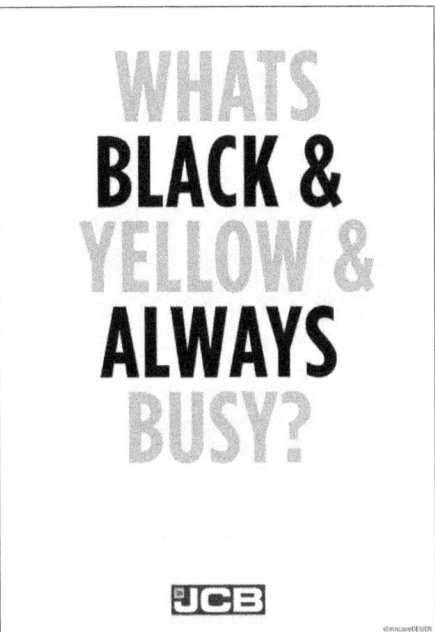

One Minute Brief of the Day: (both)
Advertise Toothpicks

One Minute Brief of the Day:
Advertise the Crabbie's Grand National

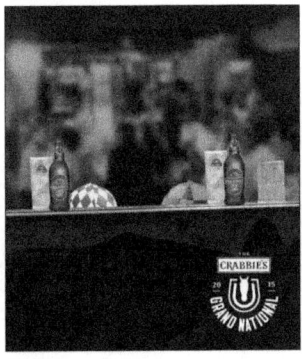

One Minute Brief of the Day:
Advertise Train Travel

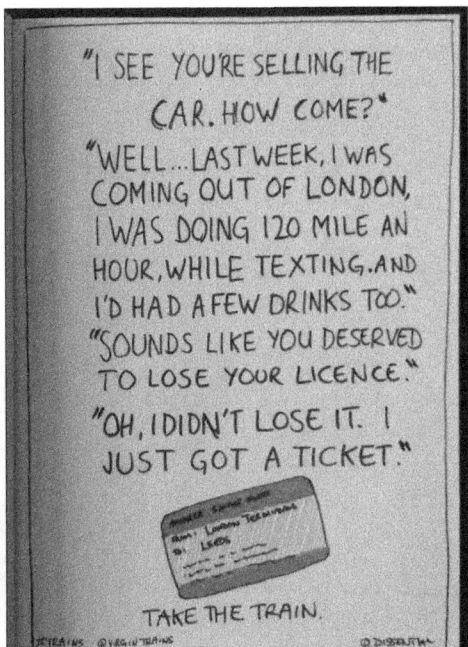

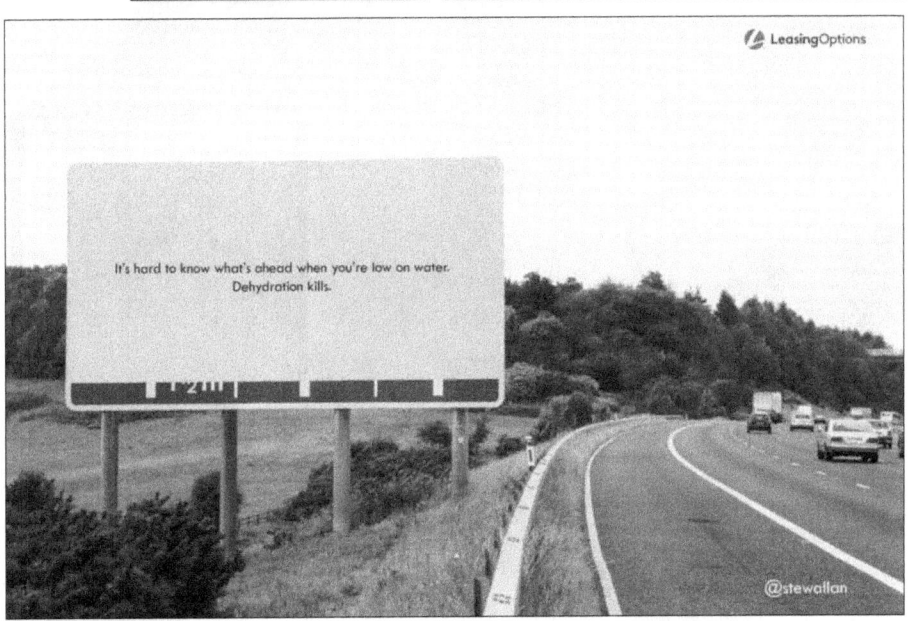

One Minute Brief of the Day:
Campaign against dehydrated driving

One Minute Brief of the Day:
Advertise Gardening Services

[Ace of spades card held up, reverse shows "PROFESSIONAL GARDEN SERVICES / CALL DAVE / 0700 000 000"]

#gardening #services

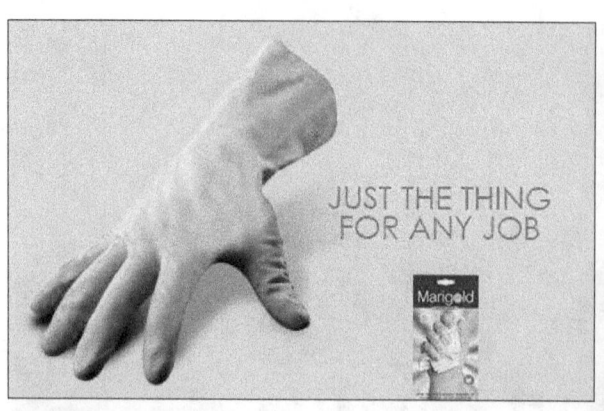

One Minute Brief of the Day:
Advertise Rubber Gloves

JUST THE THING FOR ANY JOB

Marigold

One Minute Brief of the Day:
Advertise Spider Repellant

SPIDER AWAY

One Minute Brief of the Day:
Advertise the 'Brelfie'

One Minute Brief of the Day:
Advertise Weeping Seaman Hot Sauce

One Minute Brief of the Day:
Advertise the Fresh Awards

One Minute Brief of the Day:
Campaign against Drink Driving

Shot Shot Shot
Shot Shot Shot
Shot Shot Shot
Shot Shot Shot
Shot Shot Shot
Shot Shot Shit
Shit Shit Shit
Stop!

Don't Drink and Drive

One Minute Brief of the Day: (both)
Advertise Nappies

One Minute Brief of the Day:
Advertise Knives

One Minute Brief of the Day:
Advertise Rememberance Day

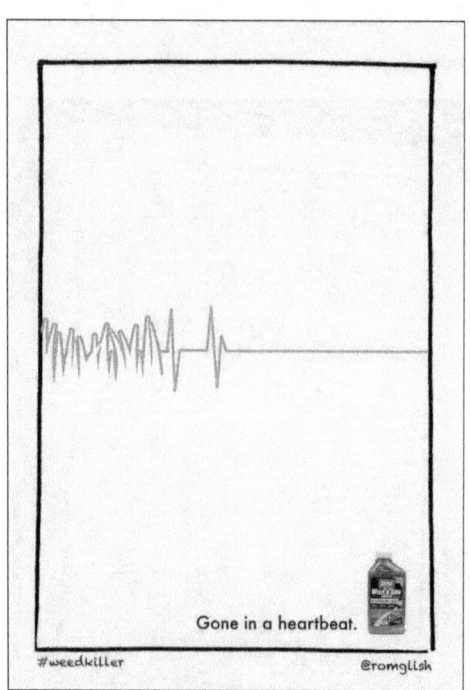

One Minute Brief of the Day:
Advertise Weedkiller

One Minute Brief of the Day:
Campaign to stop porn addiction

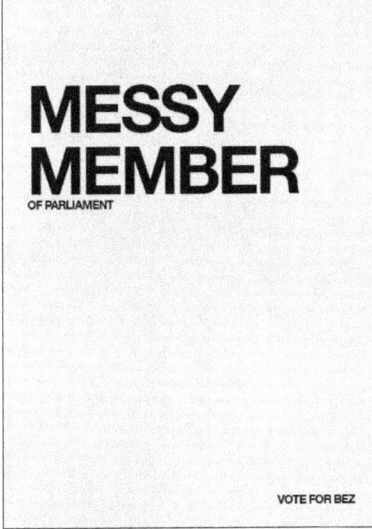

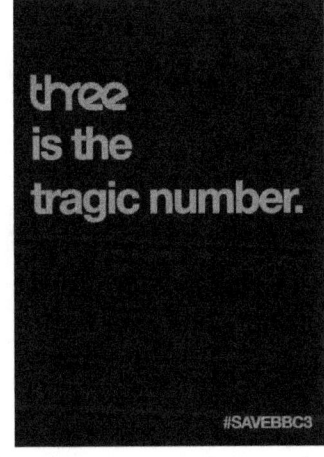

One Minute Brief of the Day:
Campaign to save BBC3

One Minute Brief of the Day:
Campaign to vote Bez into Parliament

One Minute Brief of the Day:
Campaign to vote Labour

our
country

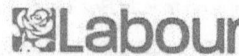

One Minute Brief of the Day:
Campaign to vote Conservative

There's never a good time to go into Labour.

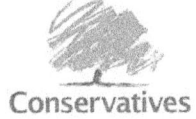
Conservatives

One Minute Brief of the Day:
Advertise a new use for the redundant tax-disc holder with WBAC

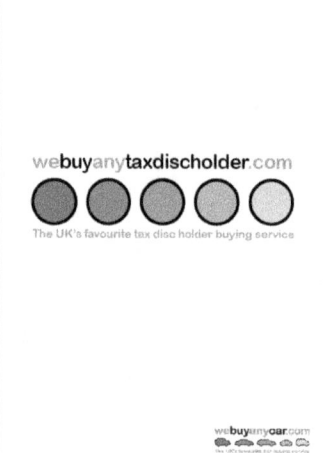

One Minute Brief of the Day:
Advertise Lucozade

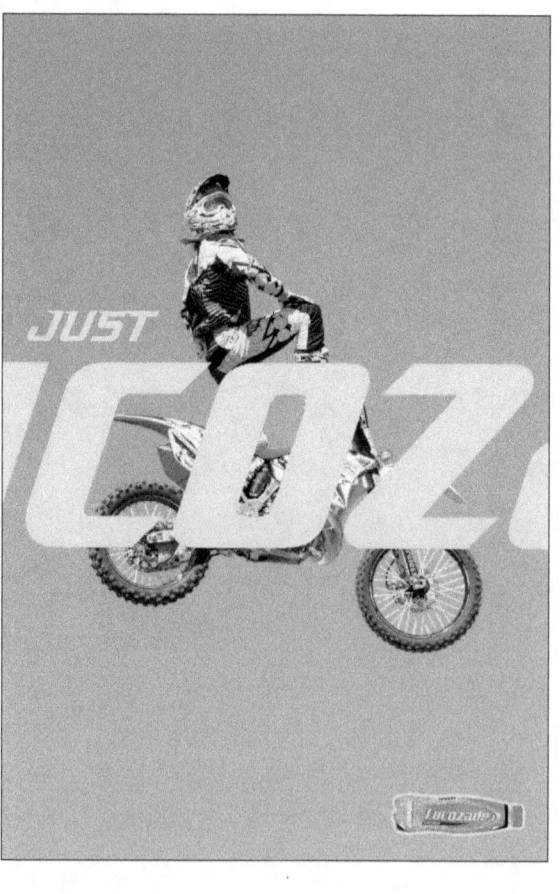

One Minute Brief of the Day:
Advertise 'The Proposers'

One Minute Brief of the Day:
Create a response ad for a brand during the eclipse

One Minute Brief of the Day:
Campaign to 'Go Sober for October

One Minute Brief of the Day: (all)
Advertise Dominatrix Services

@BOC_ATM

"The customer service was awful. I've never felt so dirty in my entire life. I'd definitely go back there."
Andrew, Manchester

"My experience was painfully bad. The conditions made me gag. I'd definitely go back there."

Tom, Basingstoke

www.dominatrix.com

"Genuinely appalled by rude staff. My room didn't even have a window. I'd definitely go back there."
John, Leicester

www.dominatrix.com

www.dominatrix.com

Celebrate Comic San's 20th Birthday for Cancer Research.

One Minute Brief of the Day:
Advertise Comic Sans 20th Birthday

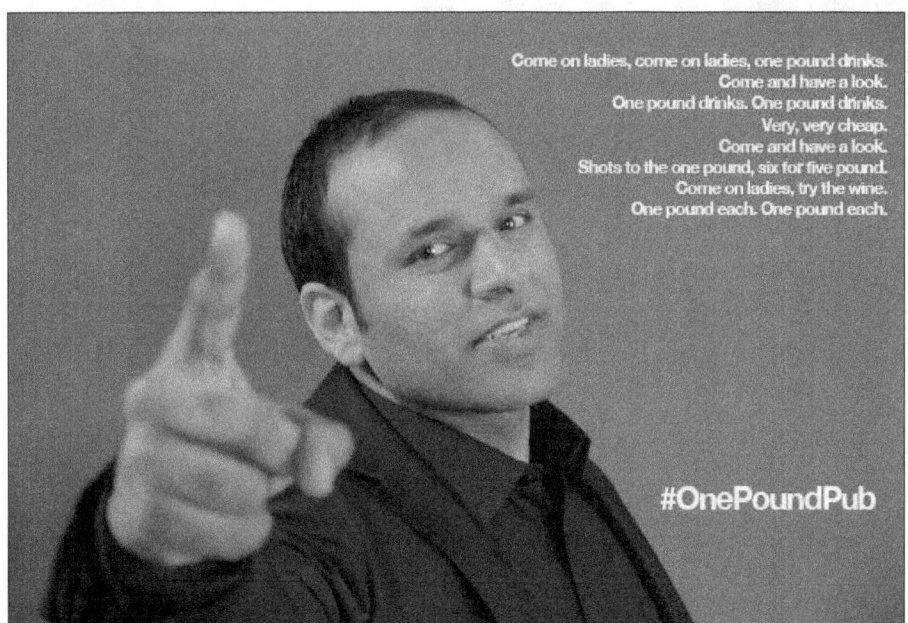

One Minute Brief of the Day:
Advertise the One Pound Pub

One Minute Brief of the Day:
Advertise Screws

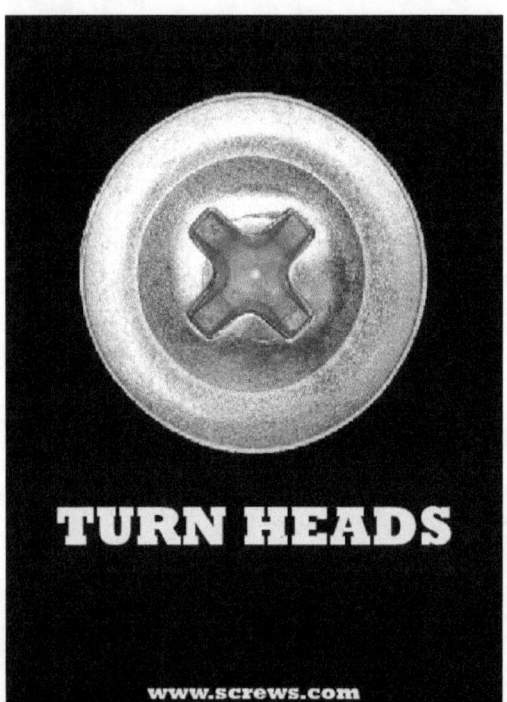

One Minute Brief of the Day:
Advertise Anal Bleaching

One Minute Brief of the Day:
Advertise the Bank of Creativity

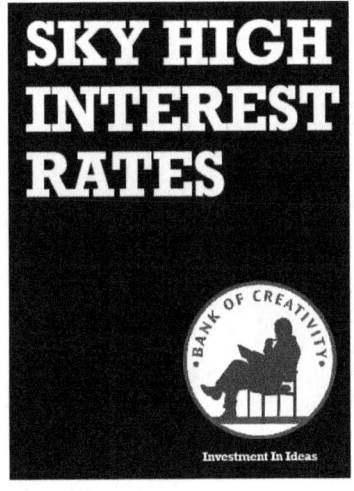

One Minute Brief of the Day:
Advertise Milk

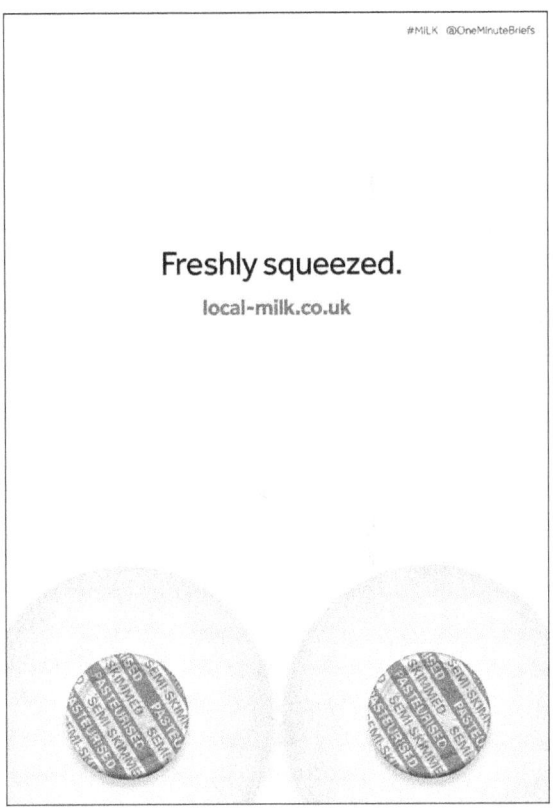

@BOC_ATM

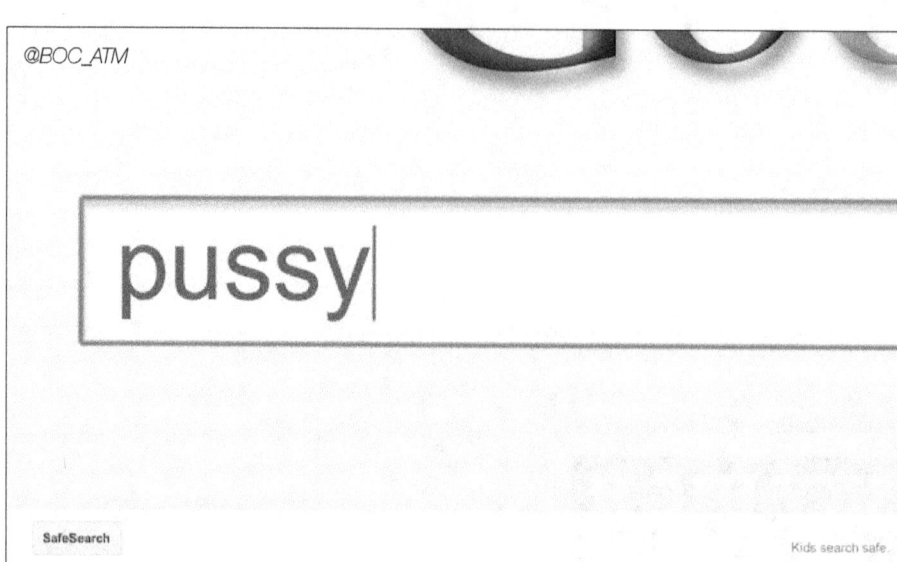

One Minute Brief of the Day:
Advertise SafeSearch

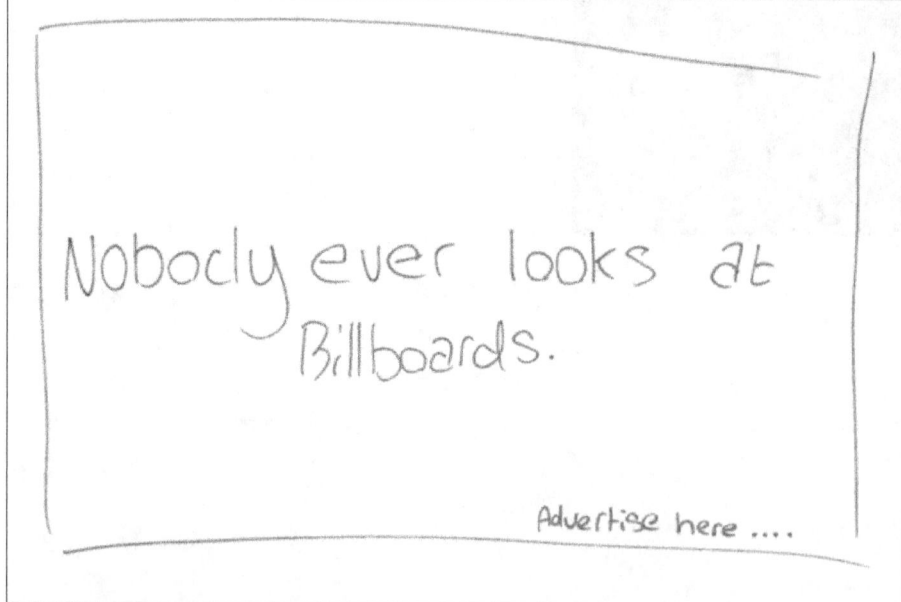

One Minute Brief of the Day:
Advertise Billboard Advertising

64.

One Minute Brief of the Day:
Advertise Pick 'n' Mix

@collect_studio

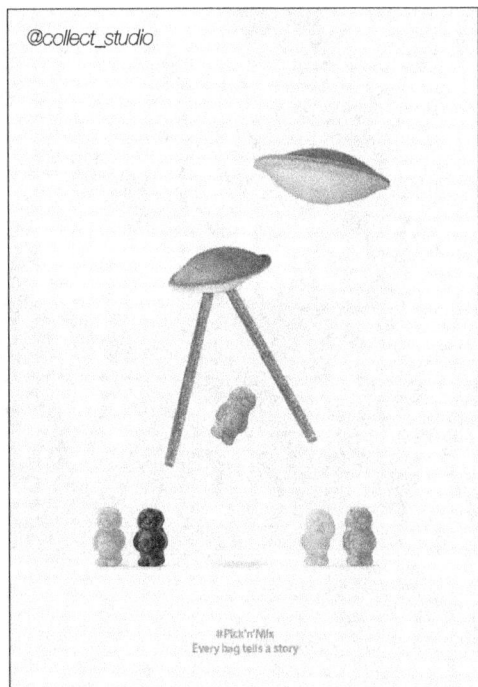

One Minute Brief of the Day:
Response Recruitment ad after Eden Hazard kicked a ballboy for timewasting

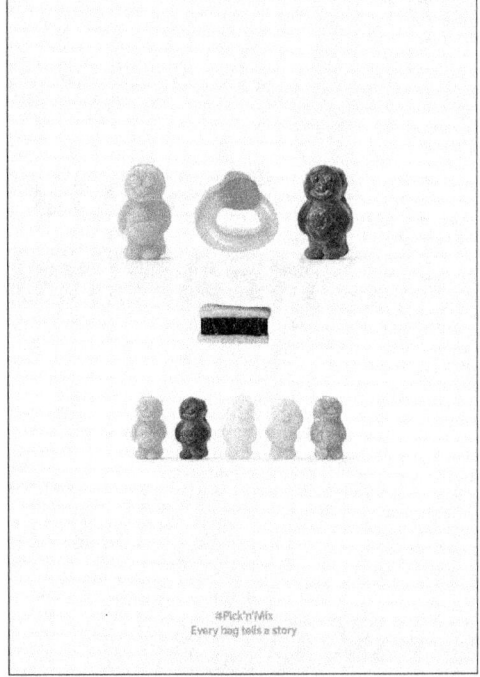

DRIVERS WANTED

One Minute Brief of the Day:
Advertise Screws

DISCOVER THE MEANING OF LIFE

USE A DICTIONARY

One Minute Brief of the Day:
Advertise Dictionaries

One Minute Brief of the Day:
Advertise Cinemas

One Minute Brief of the Day:
Advertise Pubs

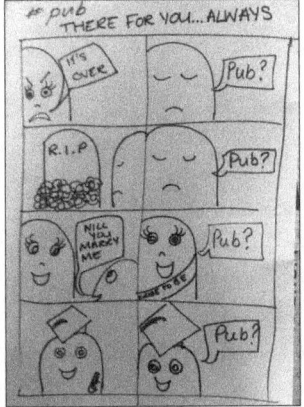
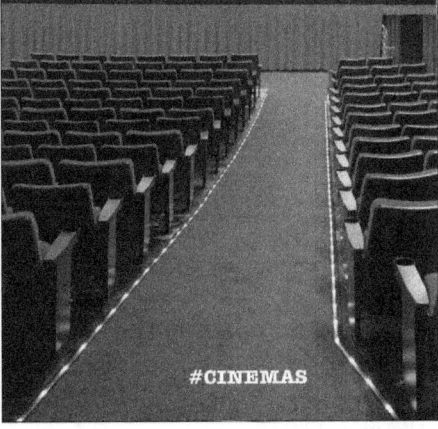

@dangreenwood

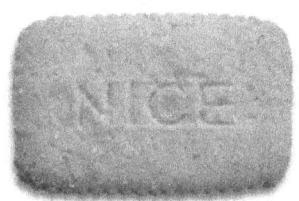
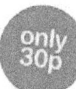

One Minute Brief of the Day:
Advertise Biscuits

One Minute Brief of the Day:
Advertise Manchester

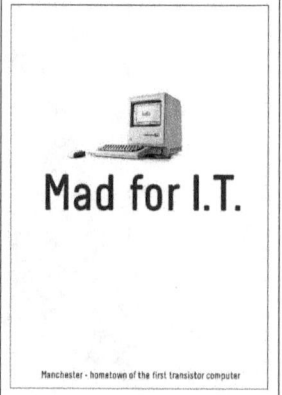

One Minute Brief of the Day:
Advertise Penpals

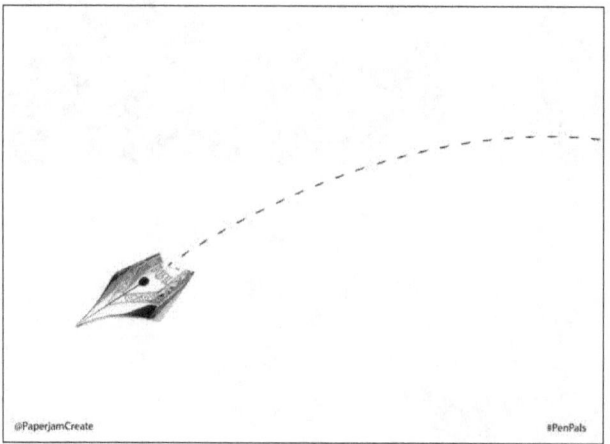

@Jay_Pegg

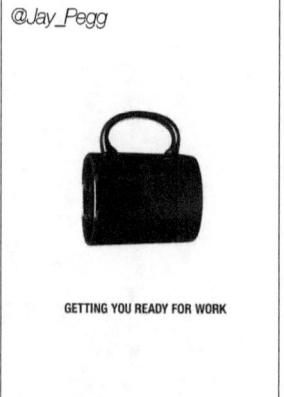

One Minute Brief of the Day:
Advertise Coffee

One Minute Brief of the Day:
Advertise Boxing

@dr_draper

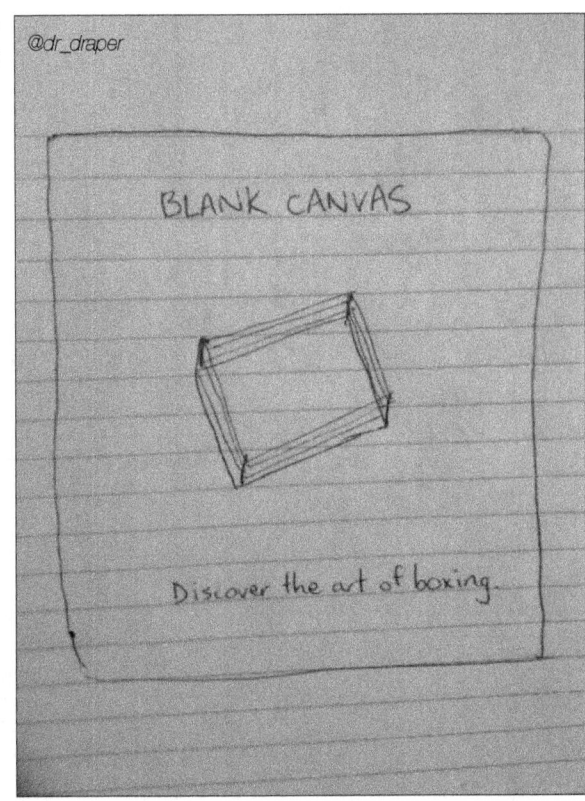

One Minute Brief of the Day:
Advertise St. Georges Day

15	16	17	18	19	20
✗	✗	✗	✗	✗	✗
22 ✗	23 ✚	24	25	26	27
29	30				
St. George's Day. 23/4					

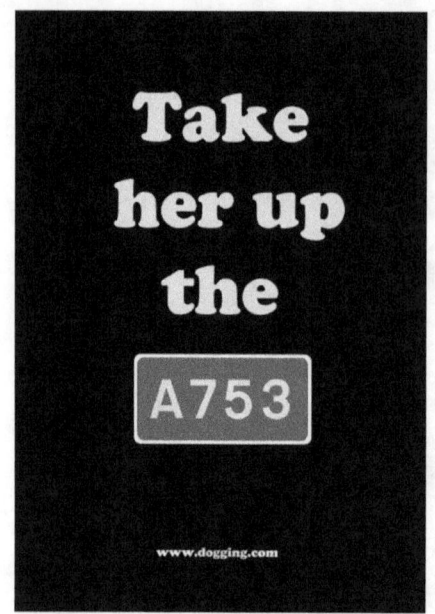

One Minute Brief of the Day: (both)
Advertise Dogging

LAY.
BYE.

DOGGING.
A QUICK AND DIRTY DETOUR.

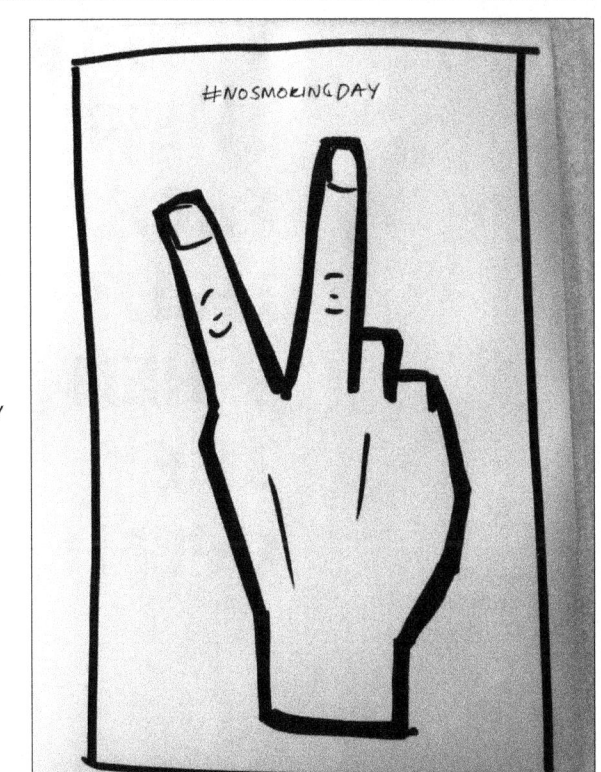

One Minute Brief of the Day: (both)
Advertise National No Smoking Day

One Minute Brief of the Day:
Advertise Fridges

Buy SOMEONE A FRIDGE FOR XMAS AND WATCH THEIR FACE LIGHT UP WHEN THEY OPEN IT

@dambritton
@oneminutebriefs
#fridges

One Minute Brief of the Day:
Campaign to vote Bez into Parliament

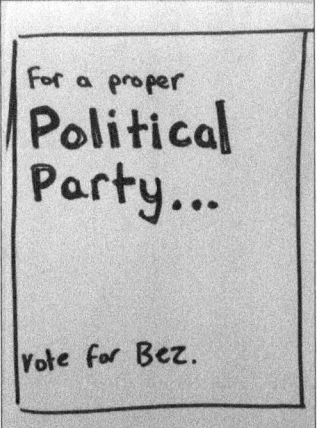

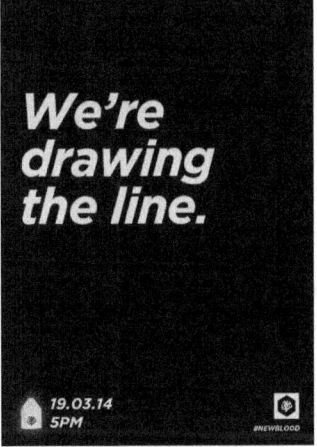

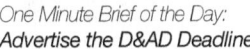

One Minute Brief of the Day:
Advertise the D&AD Deadline

One Minute Brief of the Day:
Advertise Lucozade

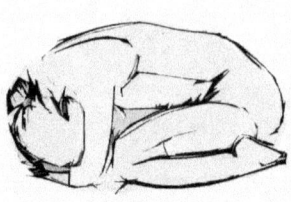

One Minute Brief of the Day:
Campaign to raise awareness and donations for 'Young Epilepsy'

One Minute Brief of the Day:
Campaign against Drugs

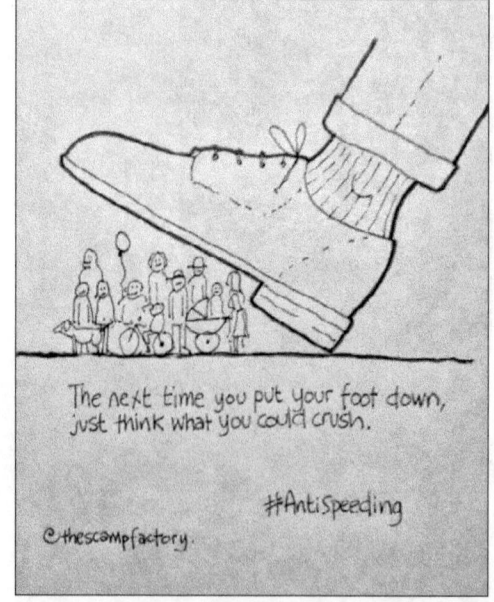

One Minute Brief of the Day:
Campaign against Speeding

74.

One Minute Brief of the Day:
Advertise Twenty Twenty Two

One Minute Brief of the Day:
Advertise High Heels

OMBLES

Without our fantastic followers, One Minute Briefs wouldn't exist. We've been able to meet some amazing people along the way, on and offline. Here are a few of them.

OMBLES

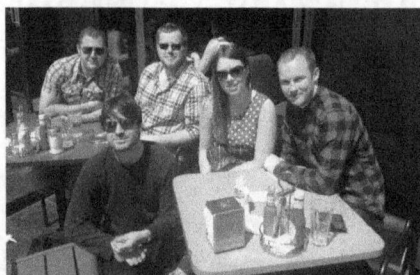

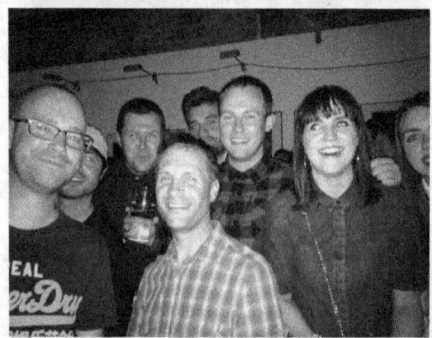

A great couple of days where I was able to support the OMBLES at the Chip Shop Awards and finally meet a follower all the way from Oz! @dr_draper

OMBMeet: London

OMBMeet: Edinburgh

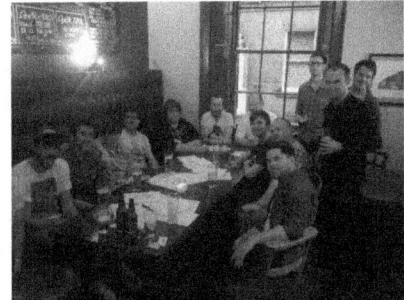

OMBMeet: Camden

Being an OMBLE doesn't stop. Even on holiday!!

The OMBLES were hungry. Chips for tea.

Now they're what you call One Minute Briefs!

Check Shane's smug face here. He knows he's got a Chip ;)

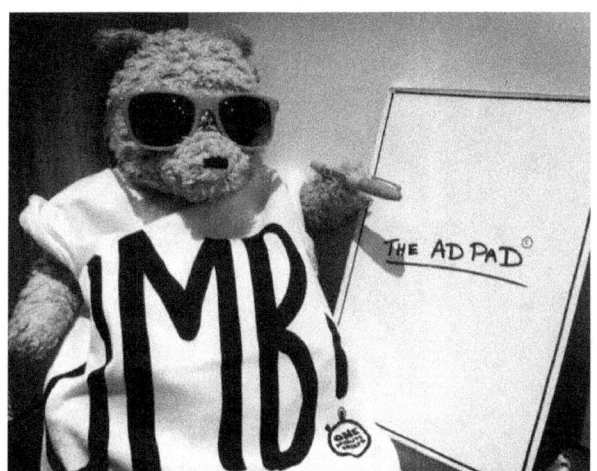

I've heard this guy wins a lot of One Minute Briefs.

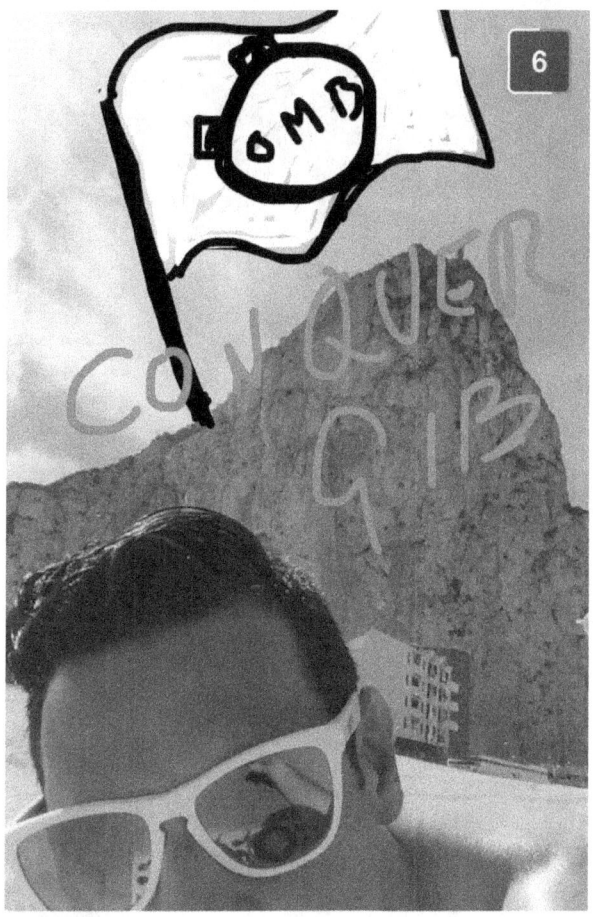

@ullger_art with a typically creative Snapchat showing his support for OMB all the way from Gibraltar.

@Charles looking cool

@katesteeth doing his bit for charity

@dambritton in MoroccOMB

Thumbs up from @JRPCD

Reppin OMB

OMB award winners

@dambritton is shocked to find his OMB tee has levitational powers

The Wonderful @WorldofOlly

@chorles just chillin

OMB TESTIMONIALS

We get some amazing comments from our followers and we wanted to showcase them here. It's great to see how **OMB** is helping people to improve their creativity as that's what it's all about. Long may it continue.

One Minute Men (and proud)

One Minute Briefs is an amazing forum for creativity. You never have to be afraid of getting your ideas out there. It's given us the opportunity to have work featured on The Drum, win prizes and has really translated into our everyday work. Our thinking is faster, we've learned to trust in our instincts, ideas, and gained the confidence to back them if we need to. Most of all it's fun and a chance to engage with like minded people. Every creative should get on twitter and have a go, after all, it only takes a minute.

- @Mac_Daddies (@Sharp_1988 & @little_scamp85)

OMB Confidence Boost

Where can I start with One Minute Briefs?

Initially, it started out as a bit of fun, something to brighten up my days as a rather frustrated graphic designer who felt I should be achieving more than I was. Plus, I'd always had an interest in advertising, and this was my way to have a crack at it.

It was then I realised that that one minute of my day was actually getting me back to thinking about the raw idea, something, i'm ashamed to admit, that i'd lost sight of for whatever reason.

The more I did them, the quicker the ideas began to flow, both with OMB, and 'real work' too.

And, my ideas started becoming winning ones too.

Pretty soon I had a book full of ideas that landed me the more fulfilling role I wanted, and, a couple of Chip Shop Awards in the process.

Then, there's the community of amazingly talented people who also take part, from students to seasoned creatives. I've been lucky enough to meet a lot of them, and it feels like we're all old friends when we do.

I'm miles away from that frustrated designer that I was, and in my opinion, it's all down to OMB. I have a lot to thank it for.

- @Matthew__Wyatt

My name's Richard Bayley and I'm a One Minute Brief addict.

I work as a designer but often don't get to show as much creativity as I would like. One Minute Briefs is a great place for people like me to learn and show off their ideas no matter how bad. Some of the ideas that I see pop up in my twitter feed are amazing and better than what we see everyday on our tv's, in magazines and on billboards. The OMBLES are great group of people and to get a favourite, retweet, like or comment on one of your ideas gives you such a buzz.

- @RichBayley80

So, One Minute Briefs what do we think about you?

Well since there's one rule and its 60 seconds we might as well try and write this in that.

OMB is a great way to help develop our creative minds, as students we are taught to always create as many ideas possible, no idea is too bad and you never know when the best one will turn up. We like to challenge ourselves to contribute to the daily briefs set, but even when we don't take part we love to just take the time and admire what others have created and learn from the different paths people take to create solutions to briefs. Something new can be learnt everyday.

This leads on to the second advantage of OMBs, the community. OMBs have created a fantastic community in which people can share their ideas, leading to many conversations. This could be a simple "great idea" or maybe some constructive criticism, but it all helps towards self-confidence and pushing yourself further.

Joining in and getting involved with the community has allowed our newly formed creative team, Amphibious, to gain not just followers, but friends within the advertising community and allowed us to begin to leave our footprint.

A massive thanks for all of the confidence and promotion that you give to our ideas.

We managed to finish this in 60 seconds, well the first draft anyway!

- @Adaptcreation

The Beauty of One Minute Briefs

At 35 years old I decided on a change of career - I wanted to be in advertising.

I hung up my chef whites, sent off a few begging letters, visited a few agencies, and along the way was lucky enough to come across One Minute Briefs. That was almost a year ago.

In that time I've learnt so much, so quickly, and managed to build up a half respectable portfolio that no longer gets laughed xstraight back out of the agency door. One Minute Briefs is a wonderfully simple idea that forces you to think on your feet, like really think, inside the box, outside the box, folding the box as if mental origami to produce something truly brilliant.

Or a load of old crap.

It doesn't matter. That's the beauty of One Minute Briefs. No matter what you produce, you're still producing. And if you produce enough of it, somewhere in that growing pile of half-thoughts and hastily scrawled-out scamps you will eventually find a gem. A gem that could change everything.

That's what One Minute Briefs means to me.

- @Gazzamatazzzz

OMB - sounds like an ad agency.

And so it is, and I'm proud to be a part of this virtual ad agency, made up of many free thinking individuals from the creative industry all around the world. Designers, Copywriters, Art directors, Artists, Students and Film-makers - you name it; we're all in the biggest creative department ever! OMB, One Minute Briefs, is a fantastic place to be. I have seen some terrific work, which is refreshing, no-holds-barred and sometimes highly controversial. I've always said that to produce good work you need to be with good people - and at OMB there are plenty of those around.
As a freelance adman, working from home for most of the time, I do miss the agency social life and camaraderie of the creative department. I'm pleased to say I get the same buzz at OMB.

- @Red_Shark

Thanks OMB!

I've only been doing one minute briefs for a few days and have already been a winner twice!

Not only does it give someone like myself a massive boost in confidence in their own work but also helps my creative thinking when other briefs tie you to limits. I've also got the opportunity to see fellow creative's work and thought process which is a rarity in this industry.

Thanks OMB!

- @Murphium

OMB - Completely changed our Twitter Presence

One Minute Briefs completely changed our twitter presence and generated interest for our cause from all sorts of places. It's an amazing concept and we were totally overwhelmed by all the ideas. This was particularly special as it was a campaign in memory of a very special supporter of Seashell Trust and the ideas all encapsulated his and our passion for accessible sport for everyone. It was the perfect way to make people think about inclusive sport and his legacy. Thanks to Nick we reached audiences we would certainly never have been able to. Heartfelt thanks to them and everyone for getting involved, it meant so much to everyone here.

- @SeashellTrust

60 words

Putting ideas 'out there' at an early stage, is positive and a lot of fun. It's even more fun to submit your ideas to real brands and other creative people - all at one central online hub called One Minute Briefs. With only a minute you're forced to use your creative instinct - its fast adrenaline fuelled idea generation at it's best!

- @Katesteeth

OMB gave me a platform to develop

OMB gave me a platform to develop my advertising and creative knowledge… in a minute… many many times. I joined an agency as an apprentice straight from sixth form and everything was new to me I didn't know people sat that sat in the office colouring in were called creatives? and got paid!?!? I started doing OMB's for fun and it enhanced my understanding of the creative process and also the way agency's work. That one crazy idea, that one nougat could be the difference between a run of the mill advertising campaign and an award winning campaign. The online community is full of creative talent from across the world that are all so humble and willing to help up and coming juniors in any position within advertising. Nick.E 4 lyf. Flash out.

- @MaxGordon94

Unadulterated Creativeness

They're that daily hit of pure, unadulterated creativeness, that does away with budgets or middlemen or any such other constraints.

It's just about the thinking. The spark. The freedom. And the buzz we all get from producing great ideas.

- @GarrickMidd

Ego Boost

For me, One Minute Briefs is both fun and a challenge. I don't have time to work on a brief every day, but I take part three to four times a week. I've even featured on the winners list a couple of times – which is always a bit of en ego boost.

As a 40-something Mum who lives in Italy, I'm not your normal OMBLE (if in fact one exists). That said, there's been a lot of talk about improving diversity in the ad industry, so perhaps I'm exactly the kind of person who should be taking part.

- @Downatheel

OMBLEavable Creativity

OMB is one of the most beneficial things a student can participate in because in a couple of weeks we can have a book of ten briefs in our book and with great feedback from all the OMB community. It's a great thing to help get students work out into the open and be a great confidence booster when your work is getting votes.

It allows us to push our creative buttons and shoot any ideas no matter how crazy. Some of the work I have seen has been terrific and some have had me in stitches. Its great to work along side such creative and talented people, each with their own style.

- @LiamBruce1

Daily morning inspiration.

OMB has become my daily morning inspiration. Overall I love the concept and I think that the output of every brief is brilliant. It's a great creativity exercise for anyone related to the advertising industry. I'm really glad OMB is growing exponentially, and as long as the briefs keep on coming, I'll keep on participating.

- @cifuentes44

The Benefits of OMB

I'm Sian and I admit it, I am a terrible over thinker. My problem is I always find myself falling into that fatal trap of my own irritating hunt for perfectionism to the point where I am the one slowing myself down with self-doubt. One Minute briefs has been a great method for removing that. Making snap calls on ideas as opposed to over-analysing them is a refreshing and much needed change to the 'bad habit' working method I found myself slumped in. It's opened my eyes as to what my brain is capable of in those split seconds between first reading the brief and that initial brain spark of an idea. Having the limitation of a minute has cut out the phase of self-doubting the idea and has instead encouraged me to trust my gut, which I have personally found to be a much more successful and enjoyable working method. It's a great confidence boost and incredibly fun. The best part though, is how it's opened me up to this amazing community of creativity, from all walks of life, that One Minute Briefs has forged.

- @SianEllenJ

Hello, my name's Damien and I'm an Omble-holic

I ditched web development to become a copywriter late in 2014. With a BA and MA in creative writing I could write long copy, fiction and poetry until my fingers bled. However, the copywriting module didn't exist when I was an undergraduate, and I felt, as I approached 40, that it would be nearly impossible to break into advertising. Dr Draper tweeted that anyone in the creative industries should be following @OneMinuteBriefs. I don't normally do as I'm told, but I'm glad I made an exception.

After some awful submissions my 13th entry was a winner for a Rosetta Stone brief. I'm now learning Spanish and writing a blog about my language learning experience for their website.

When people use the cliché 'it's not the winning but the taking part that counts,' I normally want to puke at the insincerity. I would ask you to put your bucket aside for a moment - unless you're suffering from OMB withdrawal – as the briefs are about collaboration, community, reducing the sensitivity of our egos and sharpening both our creative and critical thinking. I also learn by watching other creative minds respond to the same brief. I'm going to deny fist-punching the air when I won my first prize.

Addiction can be a wonderful thing, and I'm sure that my daily dose of OMBs will lead onto harder and more addictive advertising briefs.

The OMBLE community is fantastic, and the creators deserve all the credit and applause that comes their way.

- @DamienF75

Opportunity

As a budding creative, discovering @OneMinuteBriefs has been like discovering my long lost creative parents, brothers, sisters, and the odd nutty family member. Until now, I hadn't come across any social community that contained so many budding and current creatives, who love making ads just as much as me. The short briefs have given me the opportunity to develop my copywriting and lateral thinking
skills very quickly within a short space of time, whilst having a whole loada' fun on my lunch break. My lunch hour has been transformed.

- @TheAntJackson

I've loved every minute of it

As well as doing my day job as a creative freelancer, I regularly participate in One Minute Briefs. It's become something of a daily ritual for over a year now and I've loved every minute of it.

OMB encourages creative expression - without limits - while reminding us all that the idea is king. It pushes you to test your quick-wittedness and sharpens up the creative thinking.

Working outside the agency system, as I do, can be a solitary existence at times. But OMB has fostered a real sense of creative community and belonging.

Now in my 35th year in the ad industry, might even be the oldest OMBLE, I still relish the job that I do. So it's great to see that the growing popularity of OMB is providing a positive platform for creatives starting out on their careers.

- @PWCFreelance

Thriving Throng of OMBLES

There's nothing quite like a headline that succinctly nails your message, or a visually driven ad that instantly communicates the proposition in the mind of its viewer.

Perhaps I'm a little sad but terrible advertising makes me, well, sad.

Aside from providing a platform to create and present my own ad efforts – of varying quality – One Minute Briefs brings together a community of intelligent, interesting and ambitious people who produce brilliant, daring and sometimes hilarious advertising on a daily basis.

They're supportive, appreciative and humble. As great as the premise of OMB is, it's the people and their work that makes it what it is. I think Nick and James would be the first to agree with this.

Submitting to OMB has perpetuated my admiration of and passion for advertising. It's given me confidence and I'm extremely pleased to be counted as one amongst the growing and thriving throng of OMBLEs.

- @_JohnFord

Positive Difference

Only been doing the OMB's for a short while. I, when starting was a little sceptical in truth. I'm a little battle scarred from 20 years of industry experiences. Like us all just trying to get a little recognition or feedback can be hard to get, especially against individuals and agencies who are supported, work for top names and are on top of their game. They work hard, are talented and deserve their accolade but it can feel like a closed shop at times, especially as a solo, freelance or independent. OMB is great as it allows for an open brief and the idea to be put forward regardless. A nice idea for creatives to see others work and to show your own thinking. I personally think the efforts you guys are making are massive. It's something you no doubt have to put a lot of effort in to to make work and it bridges the gap well.

We as people need to make the most positive difference we can along the way. As creatives (and people) we sit and we are judged, poked and prodded daily with the questions of: "are you good enough" or "what else you got" and we have to fight hard for creative control. I don't work for a big brand or full-time for a well known agency. I have no awards except for 4 x OMB Wins (so far) and I am really proud of them. As you say haters will hate and they always will but some great things have been achieved by doing it for the right reasons. Keep up the good work while you are happy to do. I'm sure I'm not the only one who enjoys it.

- @JRPCD

Sense of community

For the life of me I can't remember how I found One Minute Briefs, but I'm so glad I did.

As a little bit of punctuation to break-up the working day it's perfect. It keeps the little grey cells busy and thinking laterally; it's fast, fun, productive, and there's no pressure.

Seeing other people's take on the same brief is fascinating, and there's a definite sense of community. (Naff but true!) It's reassuring to know there are other folks around who like a quick hit of creative problem-solving for no other reason but the fun of it.

I'd heartily recommend spending a minute (or so) of your time on a One Minute Brief everyday. Fair warning though: it's addictive.

- @SupercoolKP

Idea is King

I do an OMB daily. Why? Because it gets my brain in gear for the day. It's a great challenge away from day to day work where the constraints are plenty.

I think it's a great community and love to see the array of interpretations of your daily briefs.

The people who don't take part are probably too afraid they might not win and their reputations at stake.

It might be too much for their ego to take.

They need to remember the idea is king.

- Benny

New Interview Tactics

"I recently attended OMB live and took part in the tournament, a one minute brief head-to-head battle. After winning the tournament I got totally inspired by the idea, and I was interviewing for a new designer at that time. I started introducing one minute briefs to the candidates I was interviewing, on the spot. After an initial look of shock, they all relished it and we had some great ideas. It really helped me in the process of selecting the right person for the job."

- @PaulAllGood

Best thing on Twitter!

On twitter, I'm following nearly anything worth following in the creative field. Nothing is as inspired a thought as @OneMinuteBriefs. A truly genius idea that brings creatives together in a light hearted way. Best thing on twitter.

- Kevin Patel

One Minute Briefs is gym for the brain

And like the gym, it attracts some awesome fitness fiends. Flexing the mental muscle with these mini-challenges is fun and primes the mind for other tasks, so I try to take part as often as I can. I've even started applying the OMB approach to other kinds of problem solving: the constraints somehow help to sharpen my focus.

The brief is open to interpretation, so there's nothing to stifle an idea except the fear of putting it in the public domain. Idea is king here. And ideas spark other ideas, so the more in the pool the better. The important thing is to submit something, whether it's computer generated, scrawled, scribbled or assembled. Sometimes my ideas are incomplete, but I enter them, regardless.

It's incredible to think that a single word attached to a hashtag can attract so many fresh responses and in the space of just a few hours. The brief is like a small object - picked up and examined from every conceivable angle by a pretty diverse and creative community. Each daily advertising challenge invites a huge response and I'm as stimulated by the ideas of others as I am coming up with my own.

Somewhere between game and daily work-out regime, One Minute Briefs is SERIOUS PLAY. And creativity, as we know, thrives on exploration through play.

- @ShireenDew

OMB broadens my perspective

'Initially a Twitter sceptic, I have recently been convinced of its worth for creative professionals - and participating in One Minute Briefs has played a big part in that. As a copywriter in a highly specialised field, I have found One Minute Briefs to be a fantastic way to broaden my perspective, and it would not be overstating it to say these 'daily exercises' have also helped me to think more creatively at work

- @Dr_Draper

A fantastic concept

One Minute Briefs is a fantastic concept, the ideas submitted either have merit or they don't, it's as simple as that. If your concept has a great idea behind it then great you've nailed it, if not you've only spent 60 seconds on if after all!

- @TheMadMancs

How I Got My Creative Mojo Back And It Only Took A Minute

In my 20 years in advertising the one constant cry that echoed throughout the agency world was "we need more time". Time for what? Crafting, production, research, debating maybe, which are all an important parts of the process, but not to have the idea. We talk about a flash of inspiration, so why ask for more time to think?

Lately I have been joining in with an amazing Twitter concept – The One Minute Brief. One simple rule create an ad in one minute from a one word brief. But guess what? It works. It works beautifully in fact. No time to over think, just knock out your first thought post it and let the Twitter world be the judge. Fellow participants give you feedback, encouragement and there's quite a bit of friendly banter (bit like a real agency actually). At the end of the day there's a vote to decide the winner or winners, but there's no losers.
 No idea is a bad idea, in fact many of the ideas would grace the presentation room of some top advertising agencies. In my time as a Creative Director I'd have been more than happy to present then to clients. There's also a few possible award winners in there too. These are the ones that you than spend the time crafting and enhancing without losing the core concept. Which is the most important element.

Can't say what others get from it, but for me it has re-ignited my desire to once more strive to create imaginative, entertaining and informative advertising. Who knows it could open another chapter in my creative career (JWT New York let's do lunch).
My creative mojo has returned more vindictive than ever. I've produced (in my opinion at least) ideas with which I'm more than happy with in virtually no time at all. I feel sharper, more creative and I'm not afraid of failure. Because having not spent days or weeks developing and nurturing an idea I am not afraid to just produce another.
The bottomline is that, to fully unleash your creativity potential, you should stop deliberating over ideas and throw them out instead. Just like when scoring a goal and falling in love, it takes a minute to have a great idea.

- @StephenHunter21

OMB brightens up my day

These one minute briefs are excellent. Brighten up my day and get my thinking cap on and make me so much better at the 'real' work I'm doing.'

- @Jay_Pegg

My name is Gareth and I have a problem.

I'm addicted to One Minute Briefs!

Not a word of a lie. I wake up every morning excited about what the brief of the day may be. And as soon as it appears in my twitter feed my brain goes into overdrive.

There really is nothing like it. It makes you think. It stimulates the brain. It gets the creative juices flowing. And it only takes a minute of your time. It's creative crack!

If you feel uninspired and creatively stagnant do a One Minute Brief. You'll be sharper and better for it. And you'll soon be back for another fix!

An awesome exercise. A very cool concept. A daily routine that I can't do without!

And just wait until the day you actually win one!

- @Alvo_Muses

One minute you've got a blank canvas.

The next you've got a shit-load of creative splatter everywhere.
Best of all there's no mess, and it only took a fraction of the time it would take to do some proper procrastination.

For massive F-U's to unproductive procrastination, blank canvases, and inspiration vacuums choose @OneMinuteBriefs.

The more splatter the better in this thriving online community.

- @RyanCreatesCopy

Love your idea.

I've been preaching that students and creatives need
to develop their creative gut.
That's how you an hit a solution fast and know it's right.'

- Mark Moll

One Minute Briefs is a flipping marvellous idea

Whatever the brief – whether it's to advertise the army, slimming pills, or even, ahem, dogging – OMBs forces you to think quickly and sharply about the very core of the product then communicate it as effectively as you can with wit, intelligence, or sometimes just a bloody good pun. These short bursts of concentration make you think better and they make your creative work better. And they only take 60 seconds, so you don't even have to feel bad about doing one of them instead of the really important report your client needs in exactly 32 minutes. Basically, they're fun, they're clever, and they're making me sort out a portfolio so I can get a job doing stuff I love all day, rather than for just a minute of it.

- Emily Barrett

No limitations

One Minute Briefs allows us to work without limitations that sometimes stifle creativity and slow the process down.

- @TheBigCreative

Part of my daily routine

One Minute Briefs has become part of my daily routine! It's so much fun and improves creative thinking for your actual work. It makes you put pen to paper and start creating ideas, bad or good. A great technique to get the ball rolling in order to find that perfect pitch!

- @TomStorrer

Something different every day

Love One Minute Briefs! it's good to test ideas generation & it's great to do something different every day!

- @DanniyellDesign

OMB F.C.

When we were given the opportunity to enter the MPA football tournament, we just had to give it a go. So we got some followers together and went head-to-head against the creative agencies in Manchester. And, we ended up reaching the final. Not bad for our first outing!

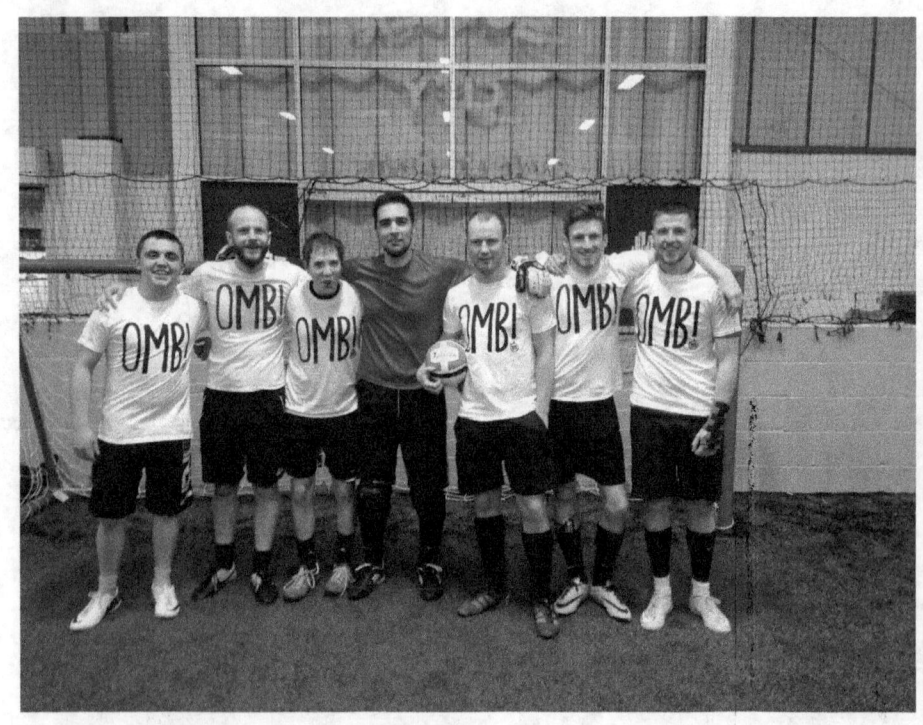

Proud of the team with their efforts in getting us to the final in our first ever tournament!! @idcircocreative man of the tournament.

Our super-sub with the best photo of the day!!

@maxgordon94 with runners-up medal (should've been winners though!)

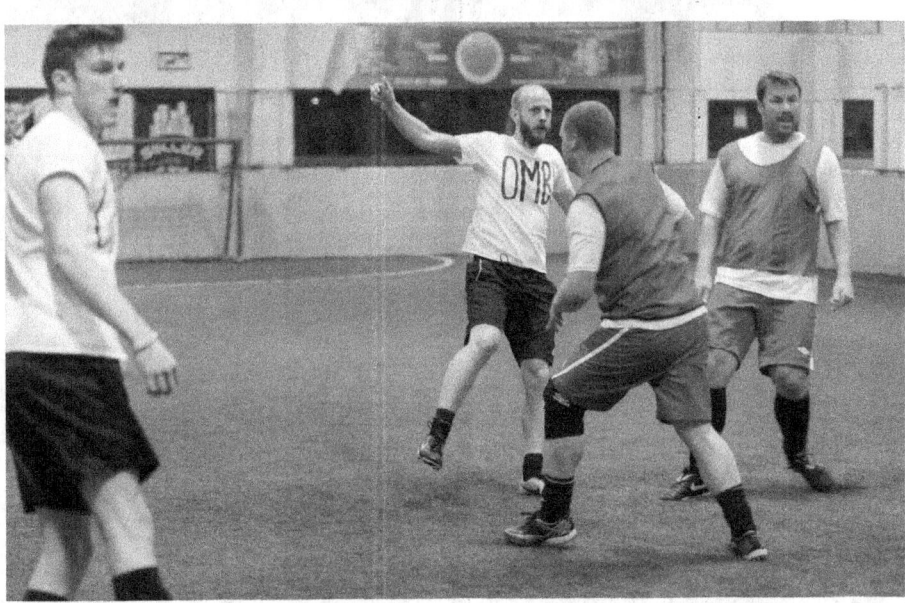

@owenjevans unleashes a thunderous volley. (Seconds later does the same into his own net.)

103.

OMBROKEN HEART

On the previous pages you will see about our first OMB football tournament, which went well until it took a turn for the worse afterwards. Friday the 13th. Unlucky for some.

I was in two minds about featuring the following story in this book but the response from our followers was overwhelming so it just had to go in.

On Friday 13th February, for the first, and possibly last time, I entered my own 'One Minute Briefs F.C.' team into the MPA Football Tournament. We were up against against a lot of the Manchester advertising/marketing agencies and, as you can imagine, I was very keen for my team to progress in the tournament. This led me to put in that little extra effort along with my teammates who worked hard to do well in the group and battle through the knockout stages with some brilliant results.

We ended up getting to the final and gave it our best shot but, unfortunately, it wasn't to be and, truth is, I had nothing left to give. I was watching the game pass me by and something wasn't quite right. I thought I was just knackered, but little did I know that the problem was a lot worse than I imagined.

We took part in the presentation and had some pictures taken with our runners-up medals but I really needed to get out of there asap as I felt unwell.

As soon as I got in my car, I felt some discomfort in my chest, which I initially put down to being unfit as I hadn't played for a few weeks. I couldn't wait to get home and was on auto-pilot as I followed my friend and team-mate Max all the way home from Manchester to Macclesfield.

The pain in my chest was getting slowly worse and I noticed my hands were clammy and I felt hot. As I'd just been playing football, I didn't think much of it and continued on my way. The journey seemed to take an eternity, every traffic light was on red and then, suddenly, I began to get aching pains down my right arm.

It was only then when I thought... could this be a heart attack? Only two weeks earlier my first ever football coach and family friend for many years, Craig Sellers, had collapsed and died of a heart attack whilst driving his car.

Of course, I dismissed any chance that it could possibly be that, after all I'm only 26. I even ignored the many signs for Stepping Hill Hospital, that I'd never noticed in my life before, to continue the drive home. On the way, my friends in the car in front pulled into the next lane to turn right and beeped at me as they shouted to let me know they were going to get a well deserved KFC. They were joking around and in a good mood but all I could do was smile

and nod. I couldn't even bring myself to put my window down. I carried on slowly as I began to get more and more uncomfortable and began to move around in my seat to try and ease the pain as cars began to overtake me. I was close to stopping and ringing someone but I've got an iPhone so, of course, the battery went! I needed to get home quickly but I've never driven so slowly in my life. So when I finally pulled up to my house I felt a huge relief, I picked up my kit and limped through the door into the kitchen (I'd also broken my toe at the football but that was the least of my worries). Using the worktop to support me I scrambled around my cupboard and found a packet of Rennies. That's right, I thought 2 Rennies would sort me out. I then crawled up the stairs to have a shower and stood in it for ages as the pain seemed to be going away.

After the shower, I attempted to get dressed and began to feel seriously weak and tired as I fell onto my side on the bed. It felt really comfortable and I thought I'd stay there for a bit but the pain in my chest was excruciating. I rang my mum but it went to voicemail and I told her in a weak shaken voice that I had massive chest pain and pain in my right arm. About a month previously she had told me not exert myself when playing football or going to the gym as this type of thing is happening more and more to younger people. I then texted her, my brother and sister to let them know what I thought was happening and, that if I didn't make it, to remember I love them.

It was then I rang my friend to ask if they could take me to hospital. At first they asked me if they could ring me back… I said, no you really need to come now…I think I'm having a heart attack. They came straight round and we went straight into A&E. I was in a bad way and could feel everyone looking at me in the waiting room. I put my head on the receptionist's desk as I was in so much pain and I was shocked when she started to ask my religion and people's phone numbers. She asked me what I did for a living and I had no idea. I was made to sit in the waiting area and I only had to wait for 5 minutes before someone called for 'Mark Entwistle'… Mark is my dad's name. I'd even got my own name wrong!

I was then rushed into 'Resuscitation' where I was immediately hooked up to lots of wires for an ECG. They also gave me a lot of morphine which gave me a wave of pain relief as I was hooked up to a heart monitor. I couldn't believe this was really happening.

Blood tests they did on me came back quickly and they had shown up an enzyme that appears when there has been an irregularity in the heart. They couldn't be sure exactly what it was and immediately put me on some medication to thin my blood. I waited for hours as I was monitored and could hear the doctors talking about me and whether or not I would be rushed over to a heart specialist hospital that night. At 4am the decision was made that I would be staying at Macclesfield Hospital. I could still feel pain but it was now under some sort of control and I was put onto a ward full of people in their 60s and 70s. At this point I was pretty emotional as I didn't understand why or what was happening to me. As well as this, I was scared to go to sleep that night as I thought I was going to die. The machines I was hooked up to were beeping all through the night and I stayed there for the next 3 days with all sorts of tests done. I had to be wheeled to the bathroom if I wanted to go and I felt totally demoralized. But one thing that made it better were the messages of support and visits by family and friends (you know who your real friends/family are at a time like this)

I was waiting Monday to arrive to go in an ambulance to Stoke Hospital where I was told I'd be given an 'angiogram' which is where you have your wrist slit and they shove a tube all the way through your vein up your arm into your heart. Nice! They said that I should be able to go home afterwards so I was feeling positive.

Monday arrived and after hours of waiting I got taken in. I was fully awake the whole time as I felt them cut my wrist and push the tube into my heart. The pain began to come back and I panicked as I watched the dye being put into my heart on the big screen in front of me. I could hear everything… and the tone of their voice changed as they had to zoom in on something on screen. Once they had finished and clamped my wrist, the doctor told me that they had found a blood clot in my heart where the blood leaves my main artery. I thought that was the end for me if I'm honest. It sounded serious and I asked them if I was going to die. They said that I'd be on a course of medication before repeating the procedure on my other arm a week later and would definitely not be leaving the hospital any time soon.

In the following week, I was subject to test after test and countless injections whilst wired to a machine. My friend brought me a colouring book for entertainment and I was brought lots of gifts of sweets and chocolate, perfect for the heart ward! I was also

forced to postpone my upcoming event and come off Twitter for a while. So I was absolutely overwhelmed when the followers at @OneMinuteBriefs had created their own brief online to support me in such a difficult time. It's something I'll never ever forget. These things added up to help me stay strong and I pestered the nurses to take me off the machine and let me walk around. I hated the feeling of helplessness and just existing each day. I did have a scare in the week as one of the tests I had showed I had a small hole in my heart but this was not the reason for the blood clot and 1 in 3 people actually have this. The CT scan was the worst though, having to lie in a tube for 45 minutes as dye is sent through your veins wasn't the best experience.

Finally, it got to the following Monday, the moment of truth. Had the treatment I'd received worked? They tried to slit my right wrist again, but when it was half cut, they decided it wasn't working and had to go into my left one. The pain as the tube entered my heart was horrendous as more dye was poured through my heart to see what was going on in there. They put a camera into it to reveal the extent of damage in my artery and whether or not they needed to put a stent in to open it up.

Meanwhile, whilst this was all going on, my mum was outside waiting for the outcome. The nurse had told her it would take 20 minutes but it was getting close to an hour due to the change of arm but she wasn't to know and was getting more and more worried. Then the nurse asked if the doctor could have a word with her. She thought something bad had happened. Luckily, it was good news, the damage to my artery and any clot had cleared. There was no need to put a stent in and there was no lasting damage to my heart. What a relief. Even if I was in severe pain from my two slit wrists!

So that was it, it had been a rollercoaster of emotions and physically/mentally draining but they said after staying one more night I could leave the next day. It was actually quite sad to say goodbye to the amazing nurses and doctors who had looked after me. They were shocked to see someone so young in there but I helped them art direct their notice board and had a good laugh with them throughout.

As I left the hospital it was the furthest I'd walked in the last two weeks and seeing people walking around was a strange

experience. I knew then that it was going to take me a while to rebuild my confidence and fitness.

The first week or two I couldn't do anything for myself and wasn't even allowed to do general housework but I started a Cardiac Rehab programme which has encouraged me to become active and build the strength of my heart muscle back up and return to completely normal life. Gradually I've started walking, driving, going to the gym and doing normal day to day tasks, as well as returning to work. I've mainly worked freelance from home but travelled to do talks at universities and pushed myself to get back to my old self which isn't easy with the self doubt and worry that something like this brings.

It is three months to the day since it happened and today I had an appointment with the doctor who performed my angiogram. I wasn't sure what to expect, but they have given me the all-clear to be an absolutely normal 26-year old and to go back to playing football and the life I had before. I am now looking forward to having more confidence and not letting anything hold me back by thinking too much about the past.

So... what does it feel like to have a heart attack at 26? Well... not great. However, in many ways, it has made me really appreciate life and changed the way I think about things. I know that family and friends will always be there no matter what, so now I feel like I can go out and do exactly what I want to do in life and make a difference. Too often I have been held back by people who don't have the same belief that I do and now this has happened I won't entertain negativity. It's actually an empowering feeling and I hope I can use this positivity to help creative people as well as being able to do great things.

I would never say that it's a good thing that it happened...but maybe it is?

Big thanks to @Matthew__wyatt who created a brief to support me whilst I was unable to run the Twitter feed. Will never forget it.

 Lambchop Creative @LeeLambchop · 3m
Well this had me filling up @OneMinuteBriefs. You have our full support and I and many others love @OneMinuteBriefs!

> **One Minute Briefs** @OneMinuteBriefs
> A message from the heart that I'd like all OMBLES to read. creative-account.blogspot.com/2015/05/what-i... RT

 Sara Keegan @SaraKeegan · 59s
@OneMinuteBriefs what did we learn here? 2 Rennies will not fix everything. SO pleased to hear that you're almost back to full health. Hero.

 1 1 View conversation

The M♦c Daddies and 8 others follow
 Liam Aldridge @Liam_Aldridge · Feb 22
All the best Nick @OneMinuteBriefs #GetWellSoonNick

Ryan and Emma and 3 others follow
 Osama @Osamayyy · Feb 21
Song of the day. My Heart Will Go On-Celine Dion dedicated to @BOC_ATM @OneMinuteBriefs #GetWellSoonNick #nearfarwhereveryouare

 Iain Robertson @yoiain · Feb 19
Keep ticking... @OneMinuteBriefs #GetWellSoonNick

Dan Scott and 1 other favorited
 Francis Milligan @FrancisMilligan · Feb 16
@OneMinuteBriefs TODAYS BRIEF #ADVERTISE #GetWellSoonNick Tweet Entries to OneMinuteBriefs - Feel better soon mate!

 John Ford @_johnford · Feb 16
Good to see plenty of @OneMinuteBriefs OMBLES getting involved to say #getwellsoonNick today. Top OMBing, even without a regular brief...

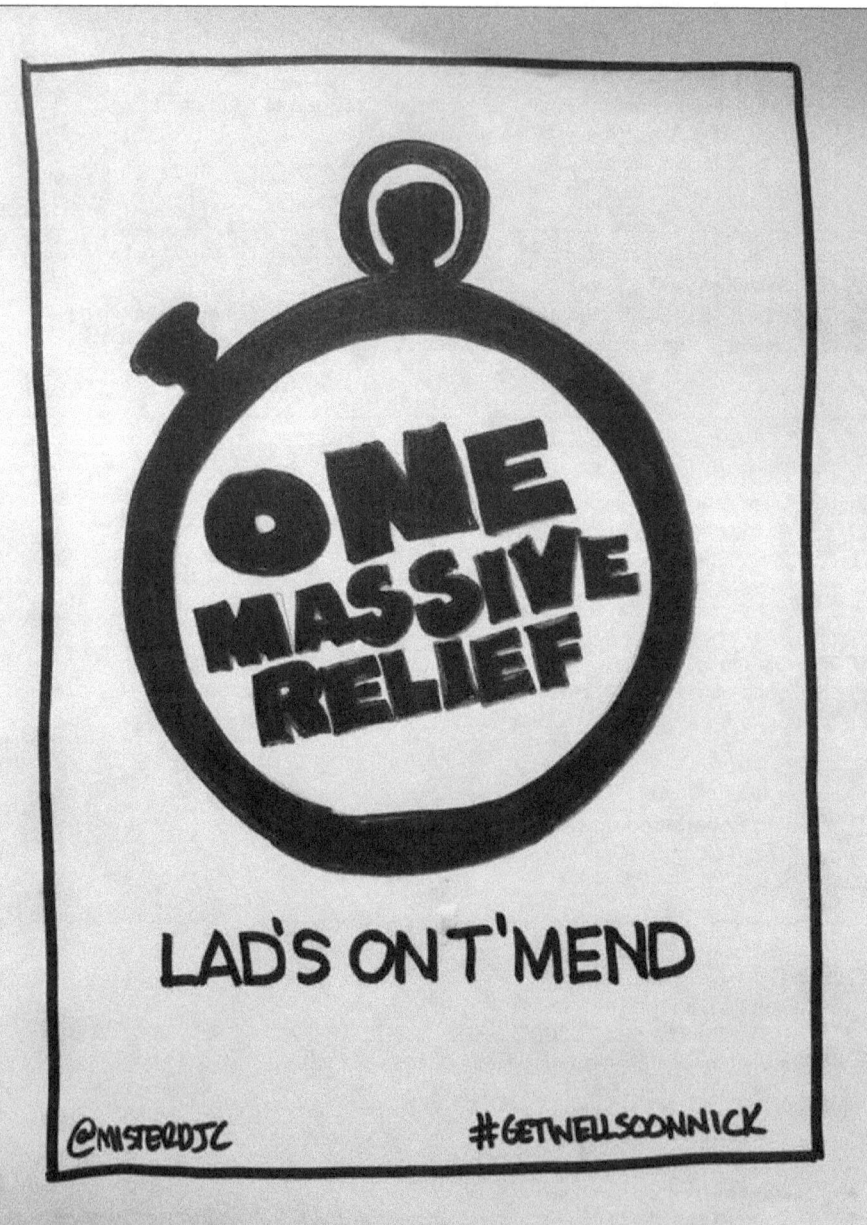

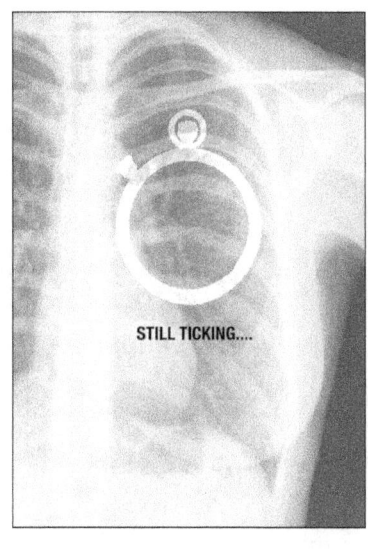

STILL TICKING....

> 16 February 2015 09:51
>
> Copywriter in need
> of an (he)art director.
>
> #GetWellSoonNick
>
> @alvo_muses

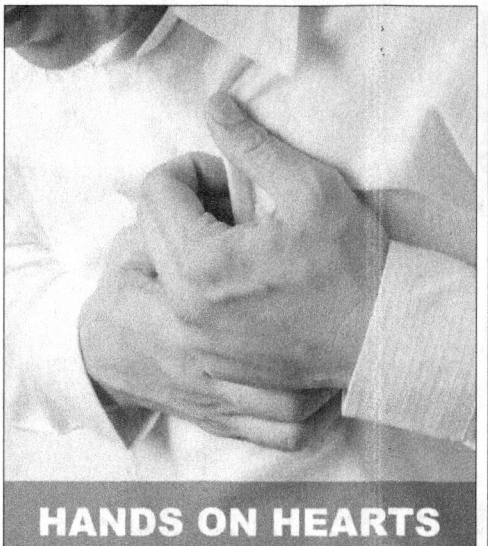

HANDS ON HEARTS WE ALL WISH YOU A SPEEDY RECOVERY.

#GetWellSoonNick @richbayley80

CORONARY THROMBOSIS?

YOU'VE GOT TO ADMIRE THAT LEVEL OF DEDICATION.

GET WELL SOON NICK

#GETWELLSOONNICK @ISSENTIAL

OMB ON TOUR

The Art of New Business - 2012
BBC Promax - 2013
D&AD New Blood - 2013
Freshtival - 2013
Twestival - 2013
Mcr Digital Talent Day - 2013
D&AD New Blood - 2014
IPA University Challenge - 2014
One Minute Briefs LIVE - 2014
Cedar Mount Academy Talk - 2014
Ideas Foundation Talk/Workshops - 2014
McCann Manchester – Advertise Yourself Campaign - 2014
D&AD New Blood - 2014
BBC Worldwide Creative Summit - 2014
BBC Wood Lane Talk - 2014
Sheffield Hallam University Lecture - 2014
Norwich University Lecture - 2014
Salford City College Lecture - 2015
Leeds Business University Lecture - 2015
School of Communication Arts Talk - 2015
D&AD New Blood - 2015

Doing my best to compete with prolific OMBLE @red_shark

Hand gestures and blank paper... what's going on?!

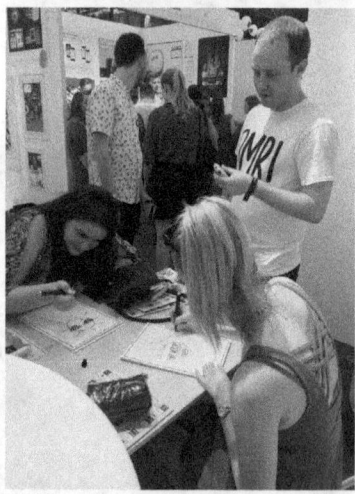

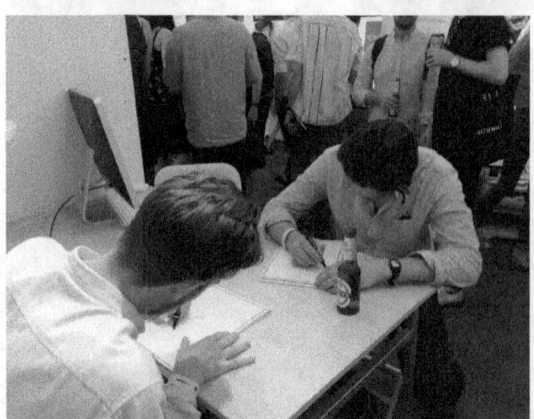

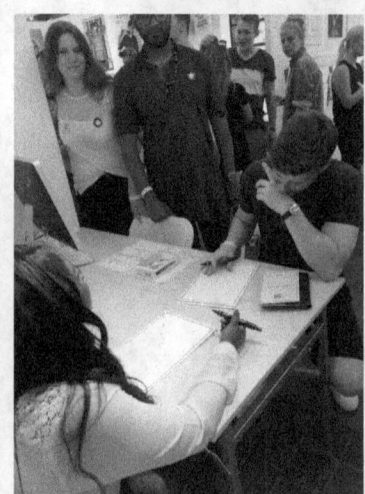

Nick going head to head with @ellensusieling

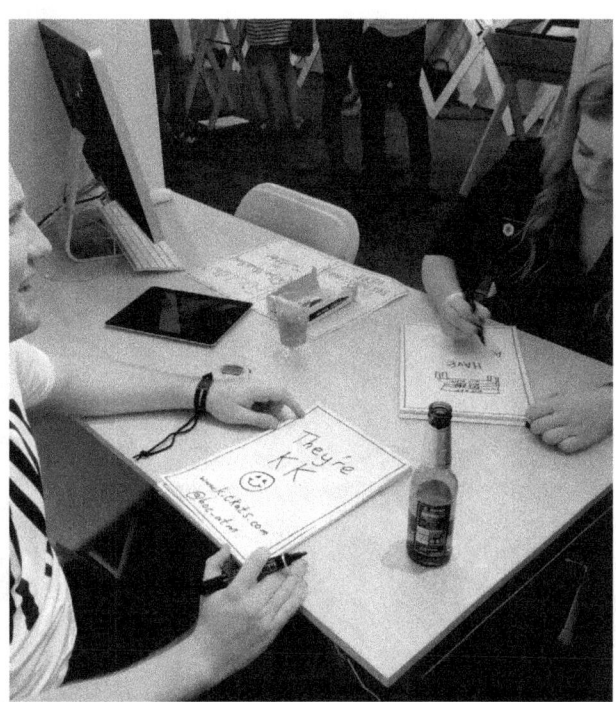

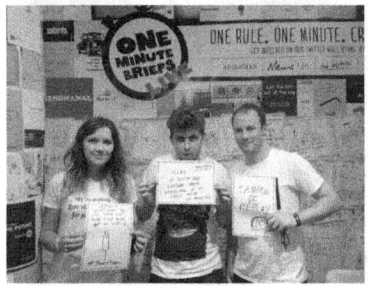

Nick going head to head with @creativebrummie and @lionarses

Smiles all round.

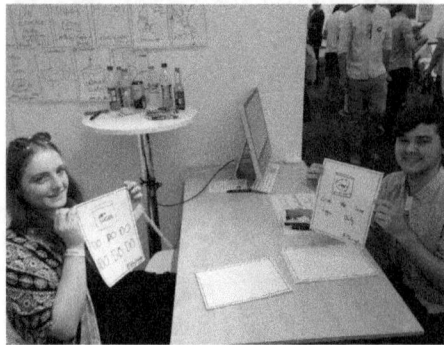

@Creativepool getting in on the act.

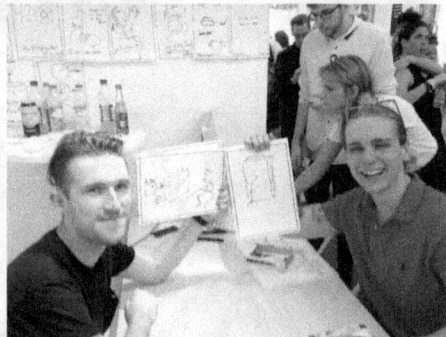

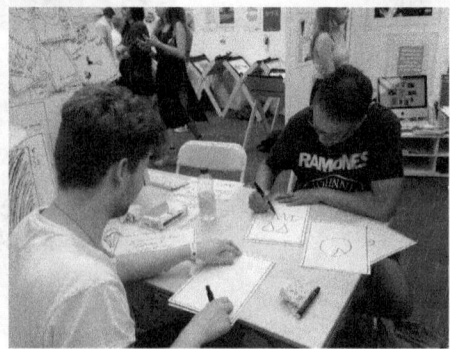

*@_HHCreative vs. @CreativeBrummie.
Very competitive.*

Intense concentration on display as the crowd take a look at what's happening.

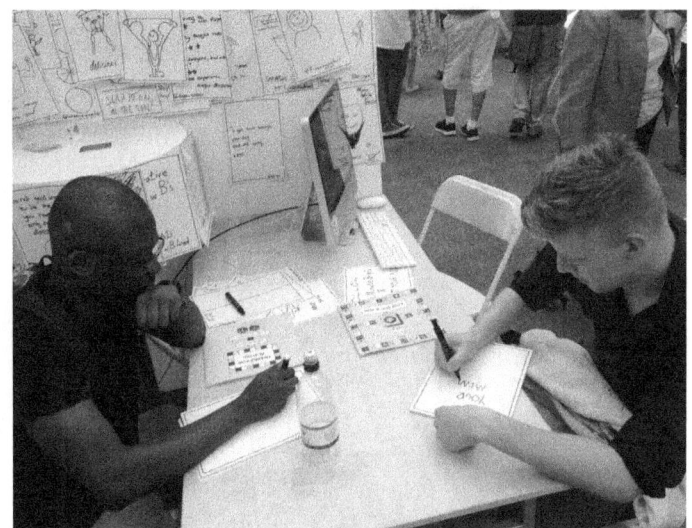

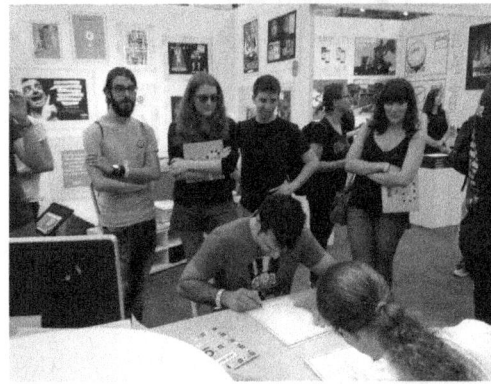

Paul Drake of D&AD vs. Nick of OMB!!

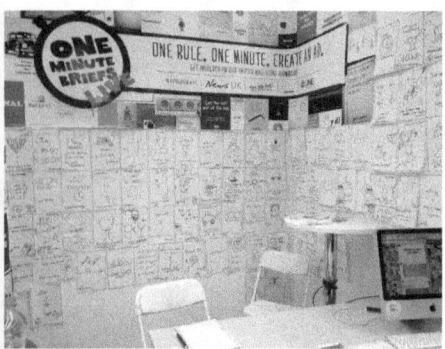

Walls full of ideas within minutes!

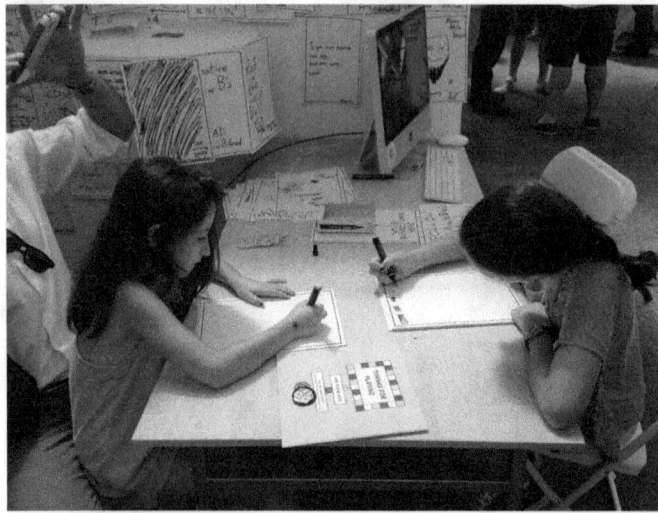

*Possibly our youngest ever OMBLES and their ideas were brilliant!!
The older people get the more they fear having a bad idea. We're trying to change that with OMB.*

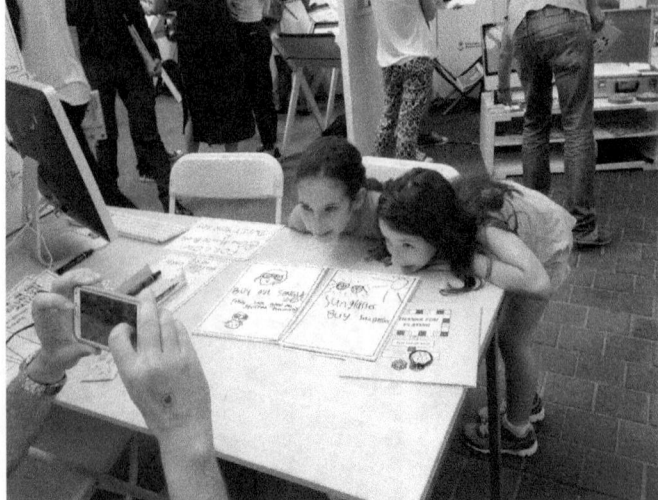

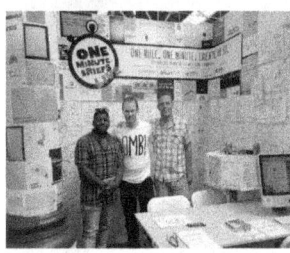

Big thanks to @aga_nat for helping out at our stand and some familar OMBLES showing up including my brother @stemount!!

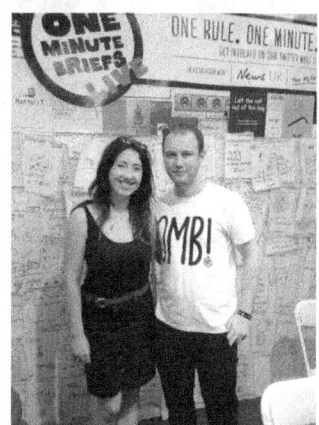

123.

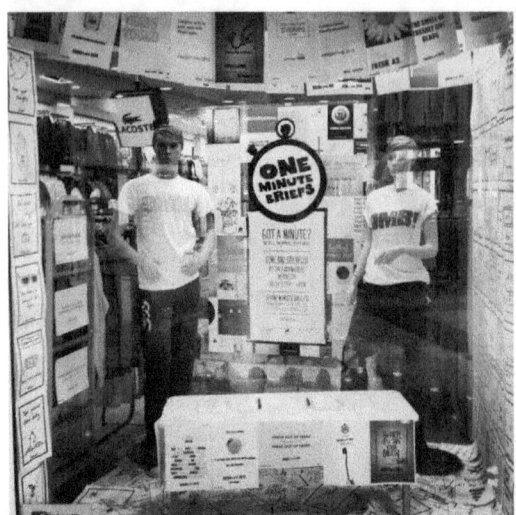

Check out the mannequin OMBLES when we filled a shop window with OMBs at the Freshtival event!

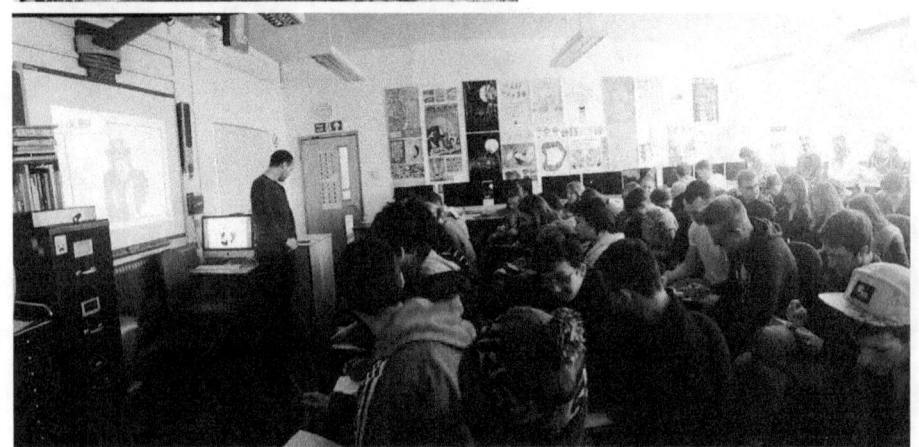

Giving a talk to the brilliant and talented Pendleton Graphics bunch at Salford City College.

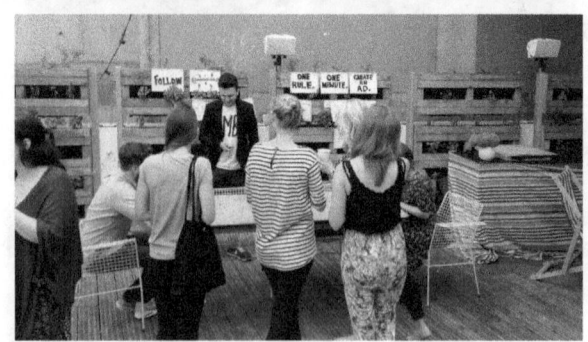

Setting up stall at the BBC Creative Summit

Amazing to meet legendary film director and now OMBLE Tony Kaye at the BBC Promax event. He ended up running our stand for us as we went to see a one of the other talks! Top man.

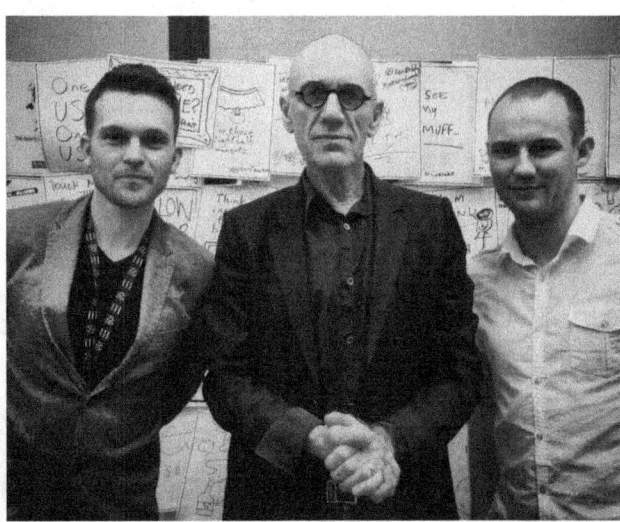

Giving a talk at SCA 2.0 in the pub! Great location!

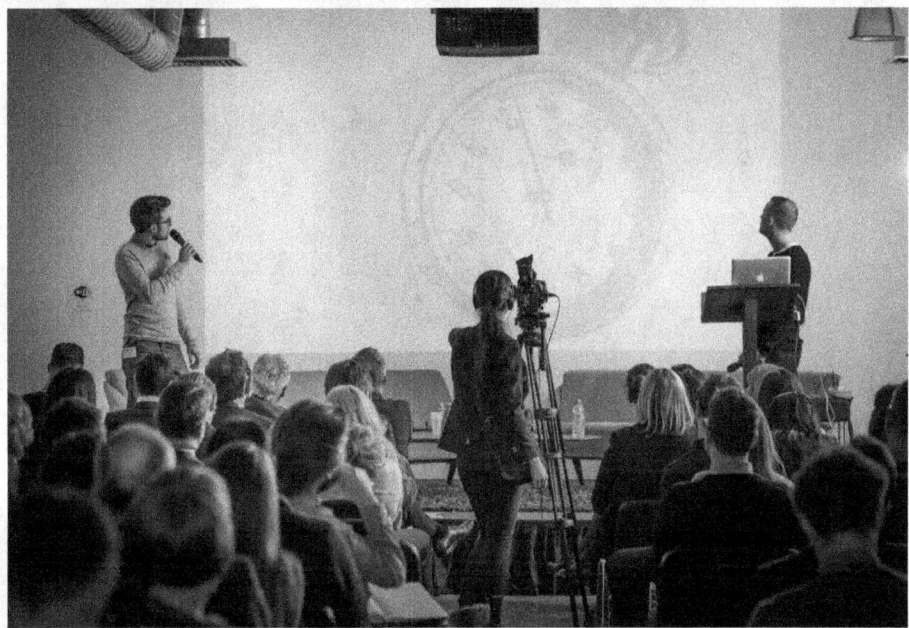

Our first ever talk at DigitasLBi and it was a big one! Didn't know we were going to be filmed. Rather nervous.

OMB TWEETS

We've been saving our favourite tweets for a while now and now we've finally got a place to feature them!

Theo Paphitis @TheoPaphitis · 4m
#SBS winner @OneMinuteBriefs are running a fantastic brief today for #SBS, prizes available - see details here: oneminutebriefs.blogspot.co.uk/2015/01/one-mi...

 1 1

Anthony Sutton @Suttsworth · 2h
Great day with nick, really appreciate him coming down. Big thanks to @OneMinuteBriefs @BOC_ATM and @PaperjamCreate for setting this up.

2 4

 dave trott retweeted you now
2h: Head to @oneminutebriefs to win a copy of Dave Trott's new book. Brief: oneminutebriefs.blogspot.co.uk/2015/04/one-mi... #worldhealthday @adhealthmag RT!

 Christopher Biggins retweeted you 16s
23m: One Minute Brief WINNER: Create @beatepilepsy #beatepilepsy ads. @chorles @onebiggins facebook.com/OneMinuteBrief... RT pic.twitter.com/JBF6P2CIFT

VCCP Kin @VCCPKin · 3m
A top concise talk from @eatbigfish. Nice nod to @OneMinuteBriefs. We need to start doing more of these. New year an all that #FurtherFaster

NareshSubhash @NareshSubhash · 14m
@OneMinuteBriefs you guys are EVERYTHING!

12:34 AM - 29 Jan 2015 · Details

 Bernie Thornton @Red_Shark · 1m
@OneMinuteBriefs A great response. All the work is sensational I think, I'm so pleased - and quite proud actually - to be involved with OMB

 Seashell Trust Thank you so much Nick Entwistle for doing this. Brilliant entries and we feel privileged to have been chosen as the cause to remember such an amazing person.
5 hrs · Unlike · 👍 1

 John Ford @_johnford · 7m
@OneMinuteBriefs @TheoPaphitis @Poppycollier @Dr_Draper OMBLES keep generating advertising that's more interesting than 99.9% of live work.
View conversation

 Ryan Wallman @Dr_Draper · 11m
@OneMinuteBriefs Jeez I'm proud to be an OMBLE this week. Some world-class ideas of late.
 1 1

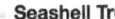 **Seashell Trust** @Seashelltrust · 4h
@OneMinuteBriefs and everyone. Thank you from all at Seashell for your inspiring entries. Over £1200 raised already!
uk.virginmoneygiving.com/SomeoneSpecial...
 3 5

Pendleton Graphics @PaperjamCreate · 8m
@OneMinuteBriefs @leaworthington awesome work, just shows that the #ombles are an ace community of v. talented people, proving it every day!
 1 ⭐ 2
View conversation

 Ollie Latham @ojlatham · 8m
No @TwitterAdsUK event would be complete without a shout out for @OneMinuteBriefs. #FurtherFaster Congrats all who got shown.
⭐ 1

129.

Laura Cripps @lauracripps 2h
New-found respect for the boys at @OneMinuteBriefs who balance OMB with their day jobs- yesterday was bloody hard!
Expand

Never Mind @Kevinho79 39m
@dognbonesjones @OneMinuteBriefs not sure about that. Love doing OneMinuteBriefs though. Best thing on concept on twitter for me.
View conversation

Joe Brooks @Joe_From_CP 4h
@dognbonesjones @OneMinuteBriefs Is it bad that I dream OMB over the weekend? Are there patches for OMB addiction?
View conversation

Alex J Thomson @alexjtdesign 37m
A couple of @OneMinuteBriefs and a few job applications today has really got me into design mode again #creativeforhire #adjobs
Expand

Stephen @stephenhunter21 5m
@ShireenDew @Dr_Draper @dognbonesjones @OneMinuteBriefs Who says you have to be cured some additions are healthy. OMBs are good for the soul
View conversation ← Reply ↨ Retweeted ★ Favorite ••• More

David Webb @Wavey_Gravy 2m
@Dr_Draper @OneMinuteBriefs @sharpstuffbits nowhere else Doc. OMB is the best place for you Creatives to test your sharpness. It's genius :)
View conversation

Gareth Alvarez @alvo_muses 2h
@dognbonesjones @OneMinuteBriefs I know what you mean. Since I started doing OMB my work has greatly improved thanks to the talent on here!
View conversation

Identica @identicadesign 4 Jul
A team of us were on the prowl yesterday @DandAD_Talent #newblood and were over whelmed by the '**One Minute Briefs**'.
pic.twitter.com/rFSG74Zw26
Favorited by Ryan Crawford and 1 other
View photo ← Reply ↨ Retweet ★ Favorite ••• More

Dannielle Wood @danniyelldesign 6m
@OneMinuteBriefs Thanks Guys! I'm an ideas wizard now thanks to doing one minute briefs ;)
View conversation

Gita @89Gita 2h
@OneMinuteBriefs will do! Only just found you guys today - Keep it up! You have actually helped me like design again ha!
Expand

Karl J Ullger @Ullger_art 3m
@89Gita @OneMinuteBriefs sane thing happened to me when I was introduced by @alvo_muses to the crazy & weird world of the OMBLES!
Hide conversation ← Reply ↨ Retweeted ★ Favorite ••• More

Shane Jones @dognbonesjones 2h
@alvo_muses @oneminutebriefs Although my ultimate goal is to become the world's first professional OMBer :-)
View conversation

Lucozade Energy @LucozadeEnergy 1m
Thanks to all who entered Lucozade Energy @oneminutebriefs - we loved them all here at Lucozade HQ! See all entries: bit.ly/1jiG3eD
Expand ← Reply ↨ Retweet ★ Favorite ••• More

Stephen Trott @stephentrott 56m
@cateca i have recently started contributing to @OneMinuteBriefs its a fun creative exercise and good way to engage and connect to people
View conversation

Liz Almond @liz545 3m
If you're not following @OneMinuteBriefs, you should be.
Expand ← Reply ↨ Retweet ★ Favorite ••• More

Stew Allan @StewAllan · 1m
I see @OneMinuteBriefs as creative brain training #sbswinnershour #SBS
↺ 1

Dr Draper @Dr_Draper · 5m
#sbswinnershour Just want to say that @OneMinuteBriefs has built up an extraordinary creative community. It's improved us all. @TheoPaphitis
★ 1 View conversation

Alejandro Cifuentes @cifuentes44 · 24s
@OneMinuteBriefs is my new daily morning inspiration! Great project for all advertisers out there! #SBS #sbswinnershour

Mark Liptrott @markemoon · 3m
@OneMinuteBriefs #sbswinnershour #SBS Bit late but OMB is fantastic to be involved in. Improves my confidence & gets my brain working faster
 View conversation

Ash Kinsella @AshKinsella · 2h
@chrisod1993 Thanks mate. I learn't about @OneMinuteBriefs earlier this year. Great excuse to flex those creative muscles in a lunch hour :)
↺ 1 View conversation

David Felton @doritosyndrome · 9m
@OneMinuteBriefs 70+ retweets for The Walking Dad entry yesterday. That's crazy! #OMB4LIFE
↺ 1 ★ 1

ideaz @faz791 · 2h
@OneMinuteBriefs @freshawards awesome news guys, congratulations! #Omblepower

Shane Jones @dognbonesjones · 8h
@OneMinuteBriefs @freshawards Well done lads, without you pair there would be no OMBLES
↺ 1 ★ 2 View conversation

132.

Iain Thorley @iainthorley · 10m
@OneMinuteBriefs BOOM! Had a call an hour after I left - got the job #OMBGetsResults buzzing

FAVORITES
2

9:01 PM · 11 Oct 2014 · Details

Hide conversation Reply Retweeted Favorited ··· More

@stute copy @stutecopy · 54s
@OneMinuteBriefs Twitter reach grew 250 to 4000 views thanks to regularly entering OMBs. Love being a part of this creative community

 1 2

Gareth Alvarez @alvo_muses · 2m
Amazingly creative, supportive community. Unique opportunities. My ad in @Campaignmag. That's @OneMinuteBriefs for you! #sbswinnershour #SBS

 1 1

Rich Bayley @richbayley80 · 2m
@OneMinuteBriefs #sbswinnershour #SBS the daily briefs get me through the working day. Amazing idea, great support and guidance.

Adam Playford @little_scamp85 · 2m
Awesome collabs. Continual encouragement. And all round top lads (obvs, they're northern!) @OneMinuteBriefs #sbswinnershour

Shane Jones @dognbonesjones · 2h
@OneMinuteBriefs OMB, the best secs I've ever had

 3 View conversation

INSPI(RED) @redcellonline · 2m
We think the future of advertising lies in the hands of @OneMinuteBriefs ! (You're loved)

133.

Ovo Energy @OvoEnergy · 4m
Thanks @OneMinuteBriefs & the fab entries we had to help us #feellovedagain We're blushing head to toe & dumping our partners for you lot.
Expand ← Reply ⇌ Retweeted ★ Favorited ••• More

Adam Cooksley @Adam_Cooksley · 8m
Some of @OneMinuteBriefs are incredible!!
Expand ← Reply ⇌ Retweet ★ Favorite ••• More

Georgia Craib @georgiacraib · 7m
. @OneMinuteBriefs have outdone themselves today. #WinterOlympics #sochi
Expand ← Reply ⇌ Retweet ★ Favorite ••• More

Paul Dodd @PaulAllgood · 1h
I'm totally loving @OneMinuteBriefs Only just discovered it, and having a lot of fun in the first week coming up with ideas. Check it out
Expand ← Reply ⇌ Retweet ★ Favorite ••• More

Kerry Congdon @kerrycongdon · 4m
LOVE the #LGBT #WinterOlympics stuff people are coming up with thanks to @OneMinuteBriefs Rock on!
Expand ← Reply ⇌ Retweet ★ Favorite ••• More

Phil Waddicor @PWCFreelance · 5m
@OneMinuteBriefs Been doing OMBs for over a year & I've loved every minute of it. Encourages creatives of all ages. Keep up the good work :)
💬 Hide conversation ← Reply ⇌ Retweeted ★ Favorite ••• More

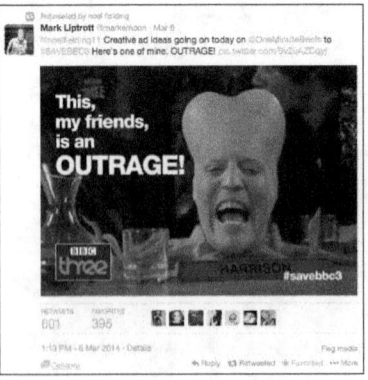

CaitrionaM @CaitrionaM · 47s
@OneMinuteBriefs are my favourite thing on twitter ever :D
Expand ← Reply ↻ Retweet ★ Favorite ••• More

Lee Martin @_Lee_Martin · 4m
@OneMinuteBriefs thanks! Looking forward to the next brief, I've only just discovered OMB. It's a brilliant idea.
View conversation ← Reply ↻ Retweet ★ Favorite ••• More

Nick Ryder @thenickryder · 8m
Big thank you to @OneMinuteBriefs for today's awesomeness. Some incredible entries for a massive issue.
Expand ← Reply ↻ Retweet ★ Favorite ••• More

Chris O'Donnell @chrisod1993 · 5m
Awesome news seeing @OneMinuteBriefs mentioned in the @nytimes blog! Their popularity is really growing, and rightly so! Really fun stuff :)
Expand ← Reply ↻ Retweet ★ Favorite ••• More

elle wagner @ellewagner · 1m
Getting a kick out of today's @OneMinuteBriefs #NewYork submissions. So many apples.. (Will give it a go myself later!)
Expand 4:31 PM - 5 Feb 2014 ← Reply ↻ Retweet ★ Favorite ••• More

Rory O'Neill @mrroryo · 1m
@OneMinuteBriefs never fails to make my day!
View conversation ← Reply ↻ Retweet ★ Favorite ••• More

tom barnett @tmbrntt · 30s
.@OneMinuteBriefs absolutely dominating my feed at the moment on several fronts. All good stuff.
Expand ← Reply ↻ Retweet ★ Favorite ••• More

Creative Network @creativenetwork · 1h
We are loving the results of the @OneMinuteBriefs
Some absolute corkers which we can only imagine some brands will run soon!
#wellplayed
Collapse ← Reply ↻ Retweet ★ Favorited ••• More

Alex J Thomson @alexjtdesign · 6m
Possibly the best #OMB ever today! Not had a chance to take part but some inspiring entries @OneMinuteBriefs
Expand ← Reply ↻ Retweet ★ Favorite ••• More

Louis @ludoyouknow · 6m
@OneMinuteBriefs The brief today is killing it, good show!
Expand Reply Retweet Favorite More

Flash @MaxGordon94 · 8m
@OneMinuteBriefs Nahh your presence helped me get a career. #Realtalk
1 1 View conversation

CaitrionaM @CaitrionaM 23m
@OneMinuteBriefs it's like visual crack, Highly entertaining! Only been following a few days too
View conversation Reply Retweet Favorite More

James Kay @iamjameskay · 5h
I won a @OneMinuteBriefs yesterday. Content, maybe. Buzzing, yes!
Expand Reply Retweet Favorite More

Emily JB @violetdarling · 1m
@OneMinuteBriefs Just got back from lunch to find a work pal doing an OMB. Was so proud I almost cried.
Expand Reply Retweeted Favorite More

Julie Small @_JulieSmall 3m
Todays @OneMinuteBriefs is awesome! Really interesting ideas coming out.
Collapse Reply Retweeted Favorite More

Stephen @stephenhunter21 · 1h
@OneMinuteBriefs I go away for a little while and when I get back I notice that you now rule the world. Congratulation for every I missed.

> Theo Paphitis retweeted
>
> **One Minute Briefs** @OneMinuteBriefs · Oct 26
> One Rule. One Minute. One ad. A social platform creating user generated advertising content. Oneminutebriefs.com #SBS @TheoPaphitis
>
> 25 16

> **BUAdvertisingSociety** @BUAdSoc · 16m
> Many congratulations to @OneMinuteBriefs for being named as a #Sbs winner by @TheoPaphitis! Go check them out!!

> **PIPEKIT~Martyn** @Pipekit · 3h
> @OneMinuteBriefs @TheoPaphitis many congratulations on your #SBS win. Welcome to a super club.
>
> View conversation

> **Gareth Horn** @Gazzamatazzzz · 5m
> @OneMinuteBriefs and @TheoPaphitis sitting in a tree... W.I.N.N.I.N.G. Congratulations, chaps! #SBS #awesomenessness

> **Shireen Dew** @ShireenDew · 2h
> @OneMinuteBriefs Congratulations for being chosen by @TheoPaphitis as an #SBS winner this week. There's just no stopping you :-)
>
> 1

> **Owen Evans** @owenjevans · 6m
> @OneMinuteBriefs Nice red-hot Theo retweet action, there lads. Nice to see things taking off - just don't forget us little people :)
>
> 1

> **Olly** @WorldOfOlly · 6m
> @OneMinuteBriefs My Twitter has exploded with all your wonderfulness. Congrats! I'll say it again, OMB agency?
>
> View conversation

138.

OMB 'LIVE'

How can you get such a close online creative community even closer? Bring them together in real life for One Minute Briefs LIVE. A night to remember.

(Well, some of it anyway... after those JagerOMBs!)

A guide for fellow

OMBLES attending

by @dognbonesjones

"Your bags are packed. After months of anticipation it's finally here, you are about to experience one of life's greatest events...OMBLive. A place where dreams become reality and you find out who you really are."

How are you feeling? Papping it and excited all at once? Awed by all the people who you could finally meet, like Nick & James? Intrigued by the prospect of meeting **@billodavies**?

Rest easy, you're not alone; everyone who has ever done a OMB has been on this journey. Here are a few pointers to help you in those all important first few hours...

BE BOLD

Some people may have met already but everyone will be just as self conscious and scared as you when they arrive, even though they may not show it. Just say, "Sup" or "A'rite?". What's the worst that can happen? *(Actually, don't think too much about that).*

So, in those first few minutes, introduce yourself to your fellow OMBLES and be approachable and open. If you have no idea what to say then just get yourself to the bar.

BE BRAVE

I know what you're thinking, "I'm north of Watford, holy shit, NORTHERNERS!" Don't worry, we're all afraid of new people and new places. OMBLive is a fresh start, a place where you can be anything that you want to be (that doesn't include you **@Ullger_art**).

Don't get caught up on what people think about you at work or university. Put yourself out there, you can guarantee **@Joe_From_CP** will.

Invite people to sample a beverage or twenty. Explore your new surroundings (just don't break anything or we'll never get the deposit back). Go clubbing. Be interested in everything and you will find others interested in you... maybe.

JOIN IN

New opportunities will be laid out for you, grab them with both hands (don't spill your beverage) and join in with as much as you can. From the **One Minute Talent Show** (have a talent prepared) to **JagerbOMBs**, try things out at least once. If it doesn't work out you will at least have a few funny stories to tell and we'll have photographic evidence to bribe you with for months to come.

Speak to new people you meet and find out why they had nothing better to do on a Friday either.

You may not like everything you try, for example, snogging Nick for a minute might not be for you but through the process of elimination you will find out what it is that you really do get a kick out of.

TRY THINGS

There is nothing that you cannot do and you should adopt the mantra that there are no failures, only experiences (what evs). You will be amazed where you can end up (**@alvo_muses**, wink wink, nudge nudge) if, when people ask you something, you just say 'YES'.

Better to do too much and reel it in, than not enough and feel like you missed the boat.

Good luck and don't worry, we're all in this together ;-)

Credit where credit's due - adapted from A Guide to Meeting New People at University | The Student Pocket Guide by Michael Muttish

We ran a brief before the event to advertise OMB LIVE and here are some of the amazing entries.

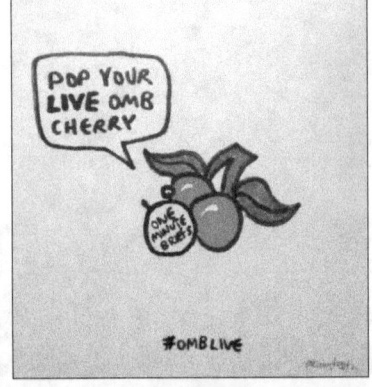

#OMBEvent
#OMBLive

Dress Code:
minuté briefs

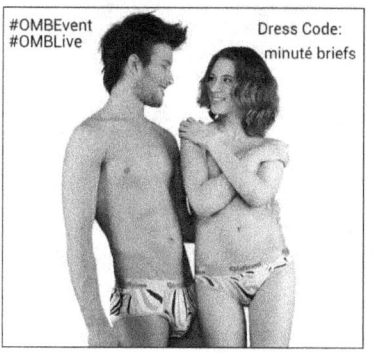

ALL YOUR FAVOURITES IN ONE PLACE

#OMBEXTRAVAGANZA @JUSTJOEL_

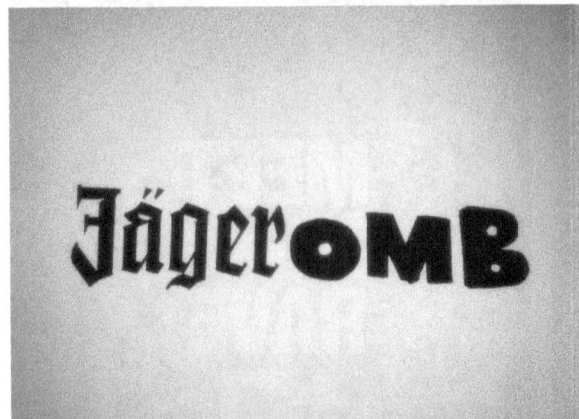

Our signature drink. After a few of these we all turn into zOMBLEs!!

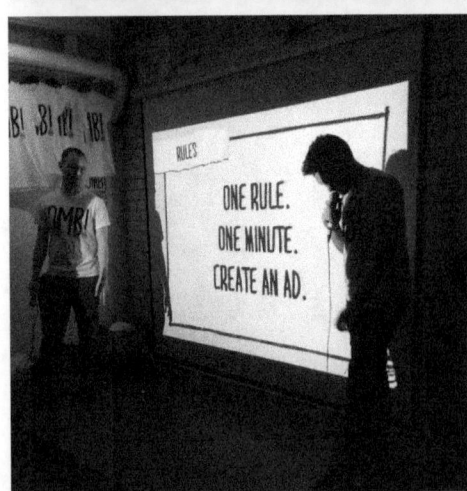

@themadmancs abusing the reserved sign!

Nick and James giving their talk. Cheered on by @neale_cp and the OMBLE crowd.

Abby, Jess and Adam loving the Live Twitter Wall

Shane upto mischief as usual.

Too many JagerOMBs @charlie100watts can't even look!

@dambritton & @bobmcduck drinking their pints before I smashed them everywhere with a football trying to do skills in the One Minute talent show!

When the One Minute talent show gets out of hand and @joe_from_essex does a One Minute Strip!!

Please can someone tell me why I was carrying around a whole bottle of wine!

80 JagerOMBs please!!

@dognbonesjones & @themadmancs were way too friendly that night!

OMBITS 'N' PIECES

Let's round off with some little OMB extras.

We've got our very tortoise mascot at OMB. His name is Blue and he helps to judge the OMB entries each day.
Here he is judging the submissions to the 'Advertise Tortoises' brief!!

OMBadges!!

OMBrews!!

OMB Awards. Coming Soon ;)

ONESIE MINUTE BRIEFS

Our next product?

We have a great ongoing relationship with advertising charity 'NABS' and produced OMB campaigns that have appeared in Campaign as well as their Christmas card.

@owenjevans with his 3D printed OMB trophy

GOT A MINUTE?

That's all you'll need to enter our briefs every weekday and the following pages are there to help you get started.

Head to @OneMinuteBriefs on Twitter.
Find out what the brief is.
Scribble down your idea.
Take a pic of it.
Tweet it.
Easy isn't it?

Look forward to seeing them!

Your Twitter Name/E-mail: _____

Tweet your ad to @OneMinuteBriefs

Your Twitter Name/E-mail: _____

Tweet your ad to @OneMinuteBriefs

Your Twitter Name/E-mail: _____

Tweet your ad to @OneMinuteBriefs

Your Twitter Name/E-mail: _____

Tweet your ad to @OneMinuteBriefs

Your Twitter Name/E-mail: _____

Tweet your ad to @OneMinuteBriefs

Your Twitter Name/E-mail: _____

Tweet your ad to @OneMinuteBriefs

Your Twitter Name/E-mail: _____

Tweet your ad to @OneMinuteBriefs

Your Twitter Name/E-mail: _____

Tweet your ad to @OneMinuteBriefs

Your Twitter Name/E-mail: _____

Tweet your ad to @OneMinuteBriefs

Your Twitter Name/E-mail: _____

Tweet your ad to @OneMinuteBriefs

THANKS FOR READING.

REMEMBER YOU'RE AN OMBLE.

@OneMinuteBriefs
oneminutebriefs.co.uk
facebook.com/oneminutebriefs
interest@bankofcreativity.co.uk

www.ingramcontent.com/pod-product-compliance
Lightning Source LLC
Chambersburg PA
CBHW060851170526
45158CB00001B/312